DRAWING PEOPLE

DRAWING PEOPLE

Victor Perard and Rune Hagman

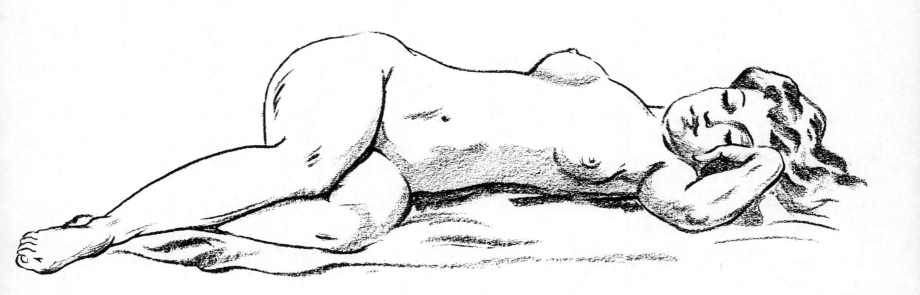

A PERIGEE BOOK

A Perigee Book
Published by The Berkley Publishing Group
A division of Penguin Group (USA) Inc.
375 Hudson Street
New York, New York 10014

First Edition: October 1987

The Penguin Group (USA) Inc. World Wide Web site address is
http://www.penguin.com

Library of Congress Cataloging-in-Publication Data

Perard, Victor Semon, 1870–1957
 Drawing people.
 1. Human figure in art. 2. Drawing—Technique.
I. Hagman, Rune. II. Title.
NC765.P39 1987 743'.4 87-7939
ISBN 0-399-51385-X

Printed in the United States of America
36 35 34 33 32 31 30

INTRODUCTION

ART is the finest way of doing anything. Pencil drawing is one of the fine arts, and the student of it should master its technique.

It is important to have the right tools to work with, a medium hard pencil H.B., a medium soft pencil 2B, and a soft eraser. Materials should be treated with respect. Learn to use your pencils deftly with varying pressure to obtain the dark and light tones.

Other Materials

India ink can be used with a pen or brush in various shades. The brushes that should be used are from No. 1 up. A

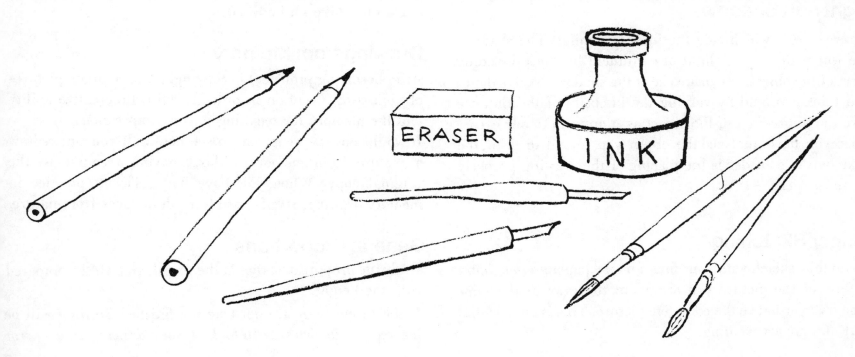

No. 6 round brush is perhaps the most useful, that is, one with sable bristles. The pen most frequently used is a croquil.

Charcoal (or carbon pencil) is often a good thing for a beginner to start with—it comes in varying degrees of hardness. Use a medium stick or pencil at first.

Look for the Lines of Action

Before starting to draw, analyze your subject carefully. Ask yourself what are the principal lines of action.

Light and Shadow

Observe from which side the light is coming. The shadows are where the rays of light are withheld by the protruding form of the object. We make use of the shadows to give depth and thickness, and by varying the intensity of the tints we give the impression of the object as it appears to our eyes.

Once you have analyzed the object you intend to draw, the next step to consider is the placing of the drawing properly on the paper.

Finger Sketching

To do this, sketch with your finger on the paper an *imaginary* outline of the picture you are about to draw; at the same time try to visualize the complete picture. This is an essential part of your art training.

Draw Lightly at First

After having followed the above instructions, take up a medium hard pencil and draw very lightly the essential lines of the subject you have selected.

If you start to draw with heavy black lines, you kill your vision of the picture. Not only are these mistakes impressed on the paper, but they are also impressed on the mind.

After having lightly sketched in your study in proper proportion and balance, start to draw accurately and with decision. Decision helps to strengthen the judgment. Above all, do not sacrifice accuracy to speed. If you hurry, you give out, but do not take in, knowledge.

Drawing from Memory

After becoming proficient in copying, try to compose pictures of your own invention in order to cultivate creative ability and the memory for recalling passing impressions.

It would now be beneficial to see how well you can redraw a picture from memory without having recourse to the original copy. When you have had sufficient practice in memory drawing, try, if possible, to draw faces from nature.

General Proportions

Study the proportions, that is, the length and width compared with the height.

If the proportions are not true the finished drawing will be marred. A good test is to *look at your drawing in a mirror*

and see it in reverse. In this way defects are more apparent. The unit of measurement used in figure drawing is known as a "head." This is the distance from the top of the skull to the tip of the chin.

The average adult figure is 7½ heads high. Remember, however, that this standard of proportion is modified by the elements of race, sex, age, and physical differences peculiar to each individual.

Proportions of the Male

The greatest width of the male figure is at the deltoids (see anatomy pages), a little below the shoulders. The width here is about 2 heads.

The width between the hips should equal 1½ heads, and the width between the nipples, 1 head.

The height of the average male figure—based on 7½ heads —should approximate 1 head for the head, 2¾ heads for the neck and trunk, and 3¾ heads for the lower ex-tremities. The distance from the fingertips to the elbow should measure 2 heads.

Proportions of the Female

The bones of the female are shorter than those of the male. The sternum (or breastbone) is shorter and more curved. The pelvis is broader and shallower, giving greater width to the hips.

The shoulders of the female are narrower, and the collar bones (clavicles) straighter and shorter. These elements give the female a longer, more graceful neck, and shoulders that slope more than the square shoulders of the male. The length of the torso is proportionately smaller than in the male. The legs are shorter and the skull smaller. The width of the female hips is about the width of the chest wall plus that of one arm, and is greater than that of the male of the same height. The female abdomen is more rounded, the thighs thicker from back to front than in the male.

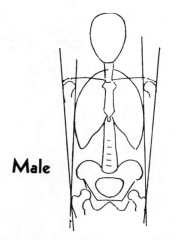

Male

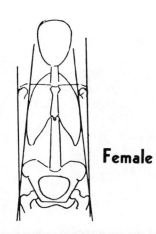

Female

Importance of Expressions

Facial expressions must be studied by the figure and portrait artist. Psychologists hold that facial expression is more an index of emotions than of character; yet habits of thought affect the face, and thoughts are expressed by looks as well as by words.

A scowl reveals clearly its meaning; when the school boy puckers his forehead, the teacher knows that he has not understood or that he does not know the answer to the question.

The actor uses facial expression to convey the various emotions such as joy, despair, scorn, anger, disdain, fear etc., which are clearly read on his face. Much of the interest in movies depends on depicting emotions through muscle control of the face.

Women study and read the facial expressions more readily than men, and are thereby accredited with more intuition. Babies and young children try to read the expression on a face to observe sympathy, pleasure or censure of grown-ups, showing that at a very early age expressions are observed and studied.

For every expression there seems to be a special movement of each separate feature. The eyebrows play an important role, the eyes are most expressive of emotions—more so than the mouth.

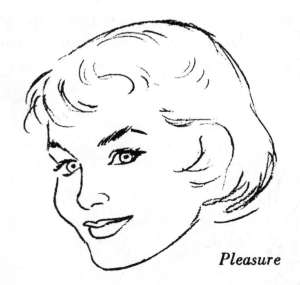

Pleasure

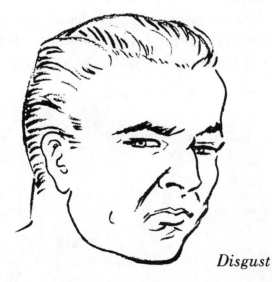

Disgust

STAGES IN DRAWING THE FIGURE

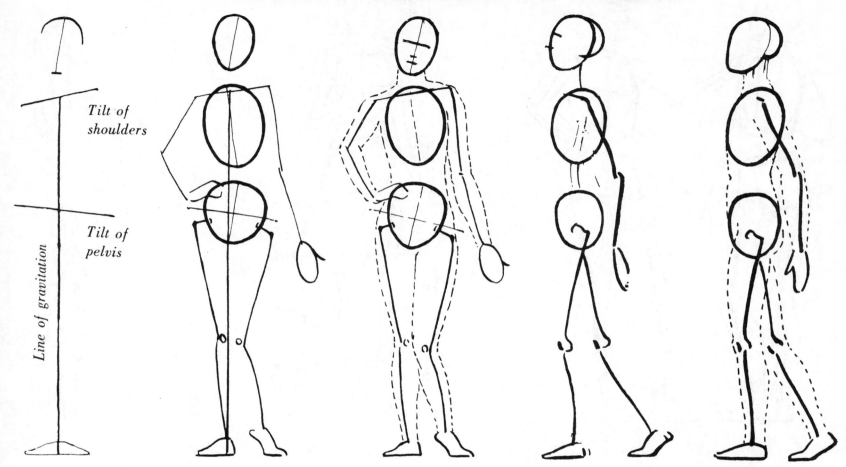

First, draw a perpendicular line to indicate the placement of the figure. This is the balance line, or *line of gravitation*. Next, indicate the action of the shoulders by a horizontal line. Leave enough room above the shoulder line for the neck and head. Draw a second horizontal line to indicate the tilt of the pelvis.

Use egg shapes for the start of the head, the torso, and the pelvis. Egg shapes help the eye to judge proportions. In the two figures at left, most of the weight rests on the right leg, which forces the pelvis and shoulders to tilt in opposite directions. The foot touches the line of gravitation.

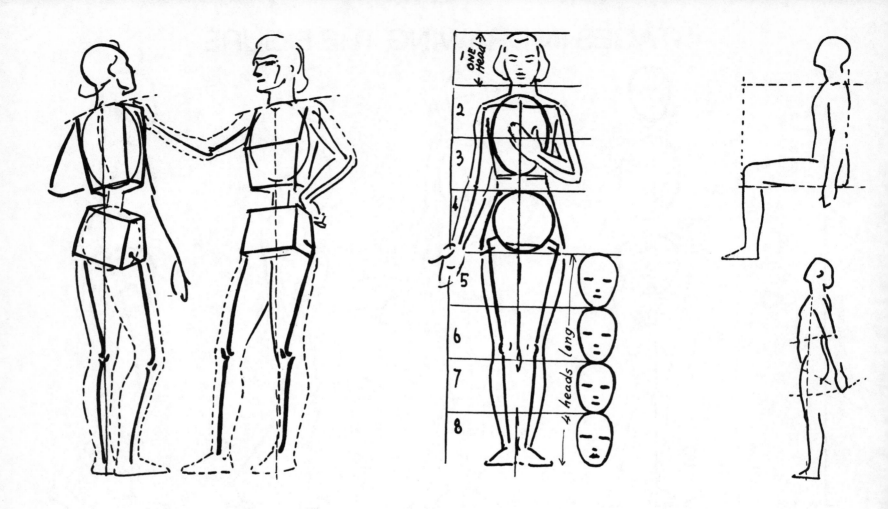

Draw stick figures lightly. The neck is lower in front than in back. A man's chin is often on a level with the back of his collar. At every turn of the head, neck-muscle forms change. In a back view, start the line of gravitation at the base of the neck (the prominent vertebra).

The average fashion figure is eight heads high. Study t[h]e proportioned figures above. Note that the breast line is t[wo] heads down; the navel is three heads down. The hand reach[es] the middle of the thigh. The distance from the shoulder to t[he] seat equals that from the knee to the back.

SIMPLIFIED SKELETON SKETCHES

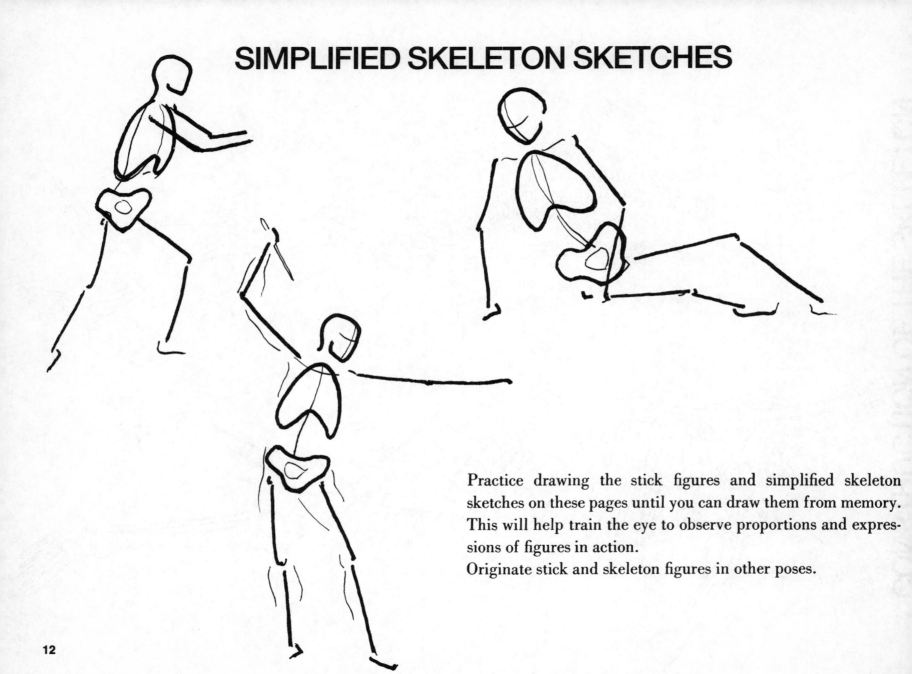

Practice drawing the stick figures and simplified skeleton sketches on these pages until you can draw them from memory. This will help train the eye to observe proportions and expressions of figures in action.

Originate stick and skeleton figures in other poses.

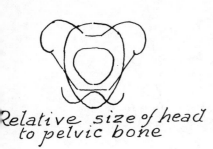

Relative size of head
to pelvic bone

Relative size of head
to rib cage

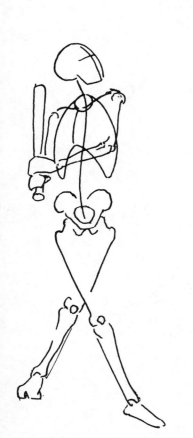

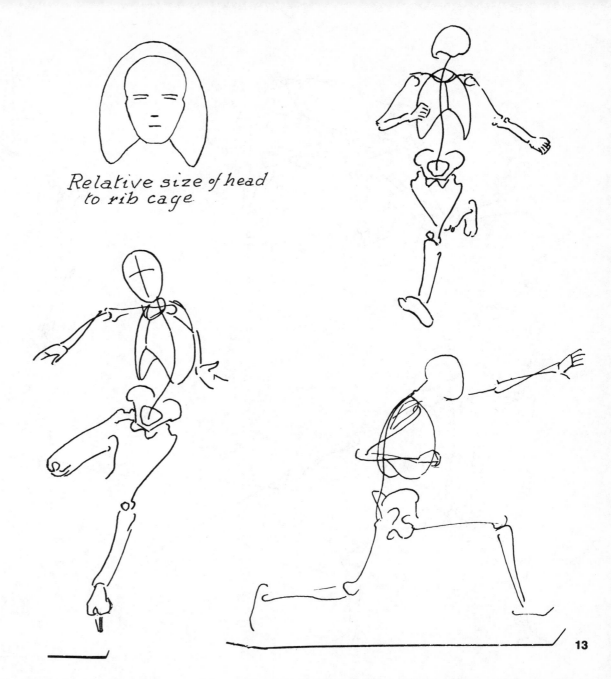

13

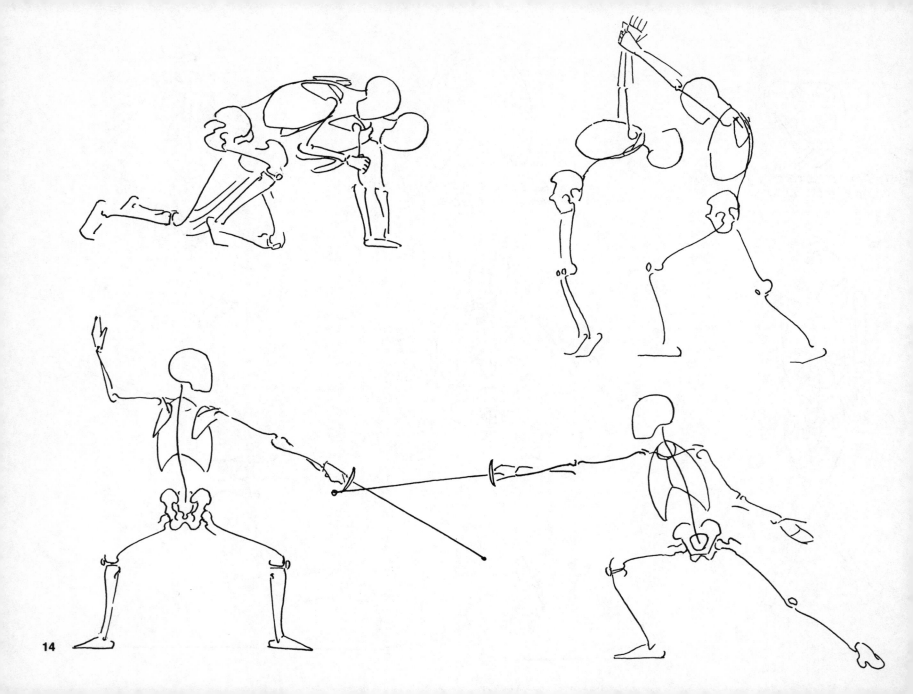

STICK FIGURES

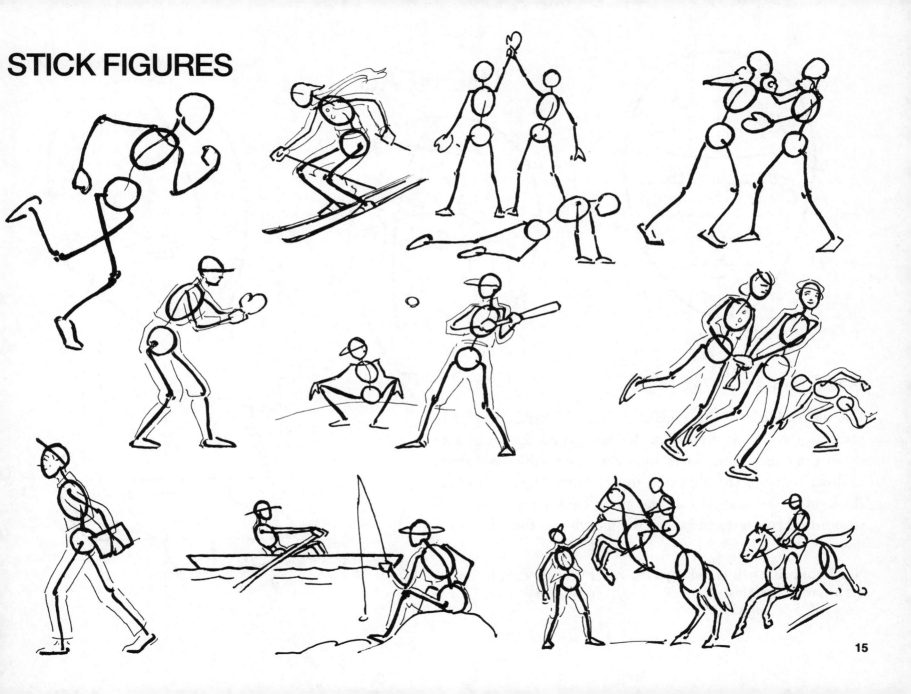

THE HEAD

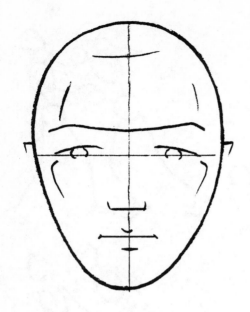

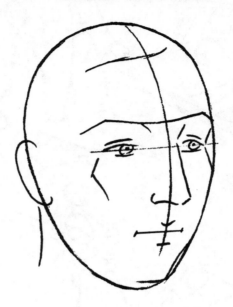

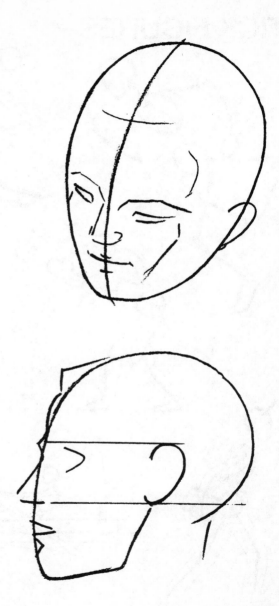

Basic Lines

Use the oval to start the general outline of a head. It helps to indicate the size and position desired. Draw the facial line down the front of the face, then the line of the eyes about midway between the chin and top of head. Draw a line for the base of the nose; divide the space between the nose and chin into three parts; and place the mouth one third from the nose.

No. 6 round brush is perhaps the most useful, that is, one with sable bristles. The pen most frequently used is a croquill. *See* page 90.

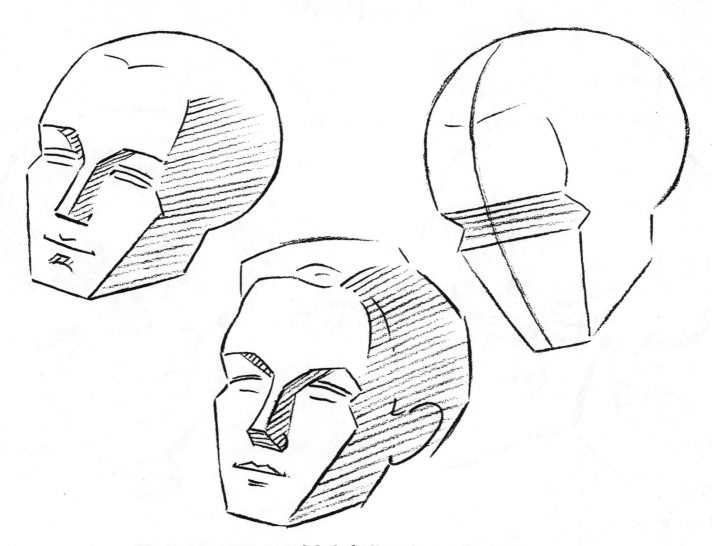

Blocked heads or simplified skulls call attention to the
third dimension, or depth of form, which gives solidity.

ANATOMY

Bones of the Face

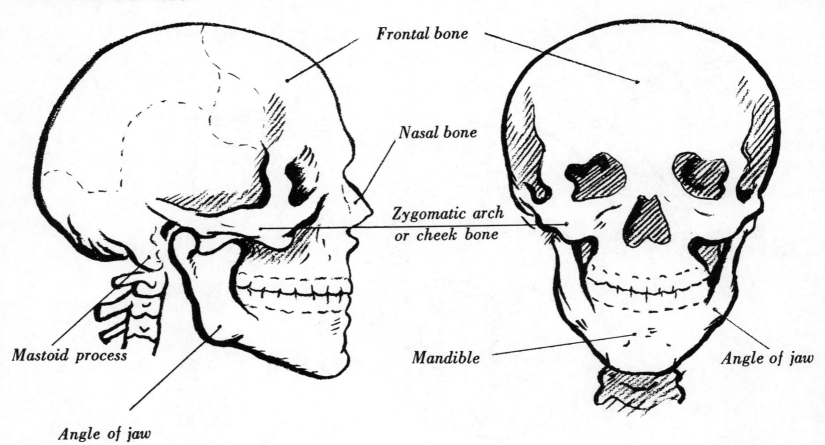

Frontal bone

Nasal bone

Zygomatic arch
or cheek bone

Mastoid process

Angle of jaw

Mandible

Angle of jaw

Muscles

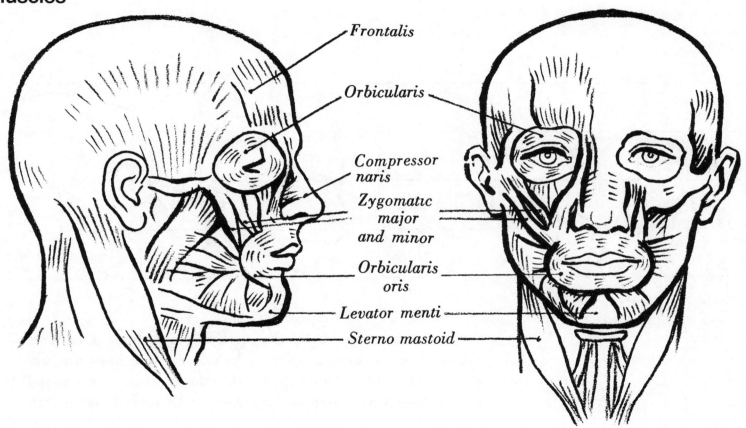

Frontalis

Orbicularis

Compressor naris

Zygomatic major and minor

Orbicularis oris

Levator menti

Sterno mastoid

Muscles control expressions, and they work by shrinking. The skin, forming the expression, is wrinkled at right angles to the pull of the muscle.

AGES AND PROPORTIONS

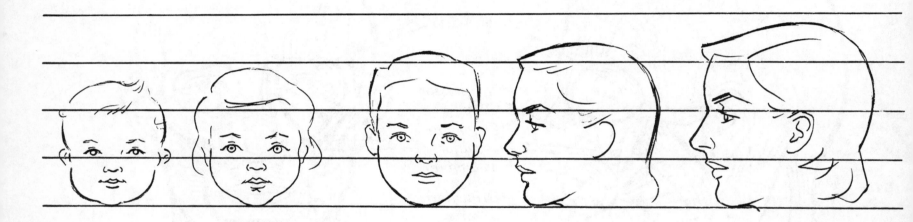

This shows changes in the relative proportions of features and skull at different ages. The nose at first is *turned up*, then straightens and begins to turn down. The ears are round and then lengthen; the eyes are gradually placed higher with age.

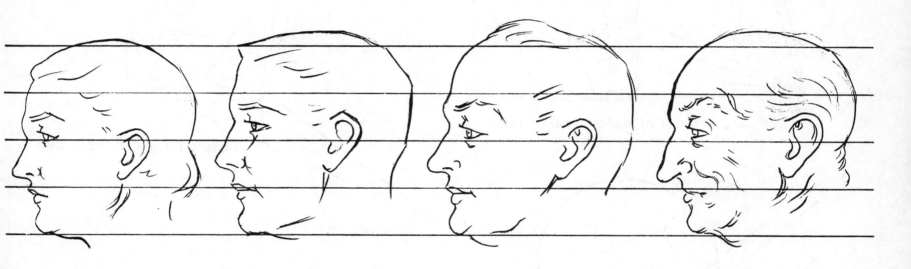

In middle life fat accumulates and fills out the features; with time, the skin loses its elasticity and wrinkles more easily. The jaw changes form and sinks in and the mouth gets larger. The cartilage between the bones hardens and reduces the height.

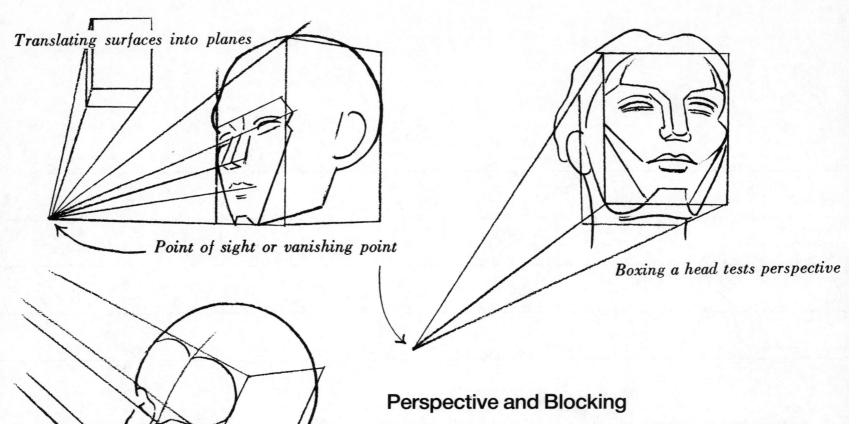

Translating surfaces into planes

Point of sight or vanishing point

Boxing a head tests perspective

Converging lines meet at vanishing point

Perspective and Blocking

All forms are affected by perspective. Objects appear smaller as the distance increases, and what is nearer to us increases in size. The first thing to bear in mind is the eye level, or horizon line, to which the lines converge. If you see under an object, your line of vision or horizon line is low; if you see above the object, your point of sight on the horizon will be high.

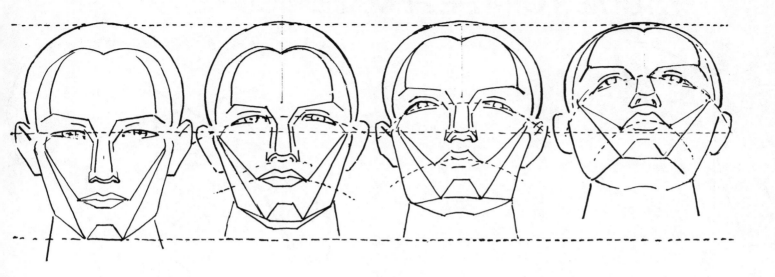

Illustrating the modifications of the planes of the face when the head is turned in different positions

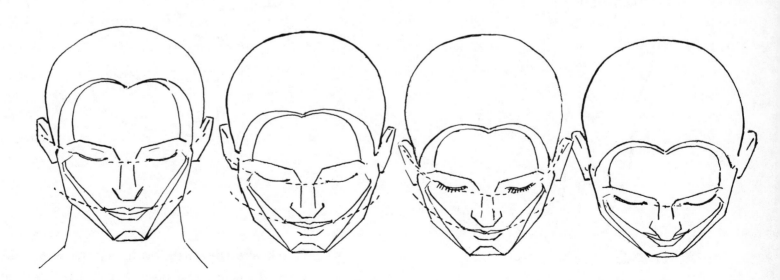

STUDIES OF THE FEMALE FIGURE

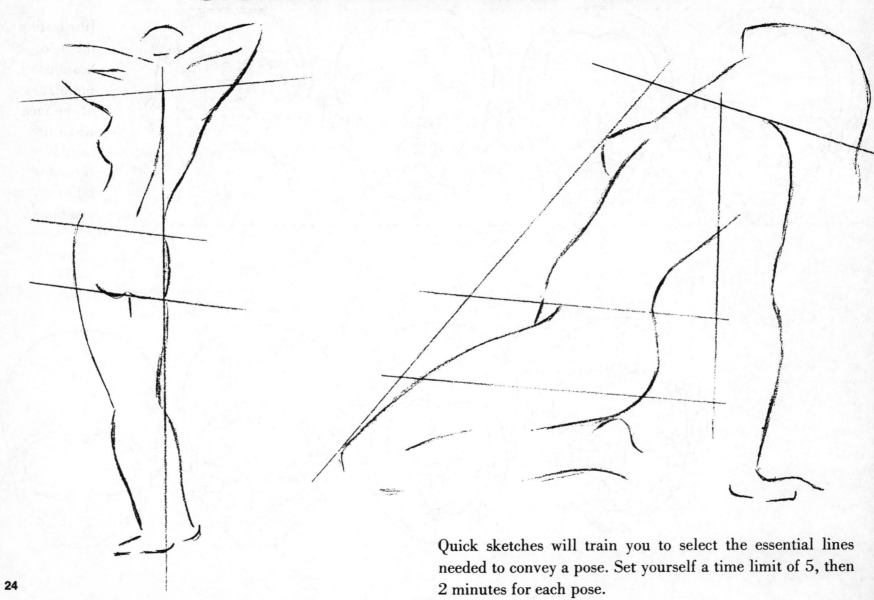

Quick sketches will train you to select the essential lines needed to convey a pose. Set yourself a time limit of 5, then 2 minutes for each pose.

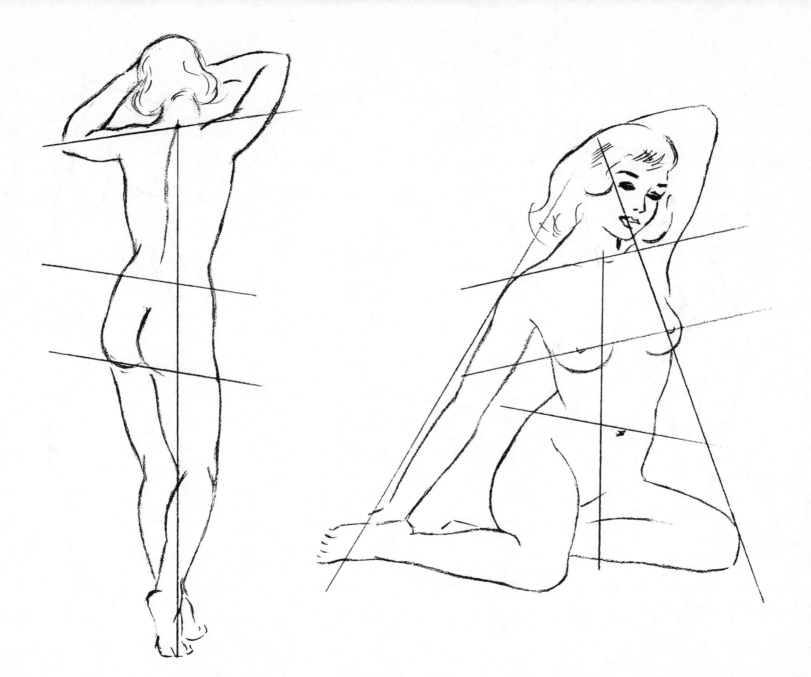

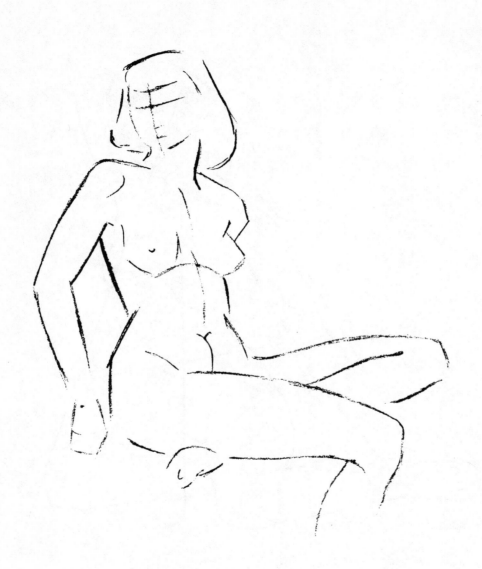

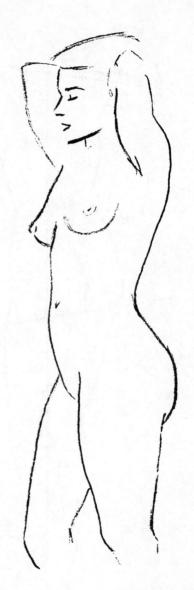

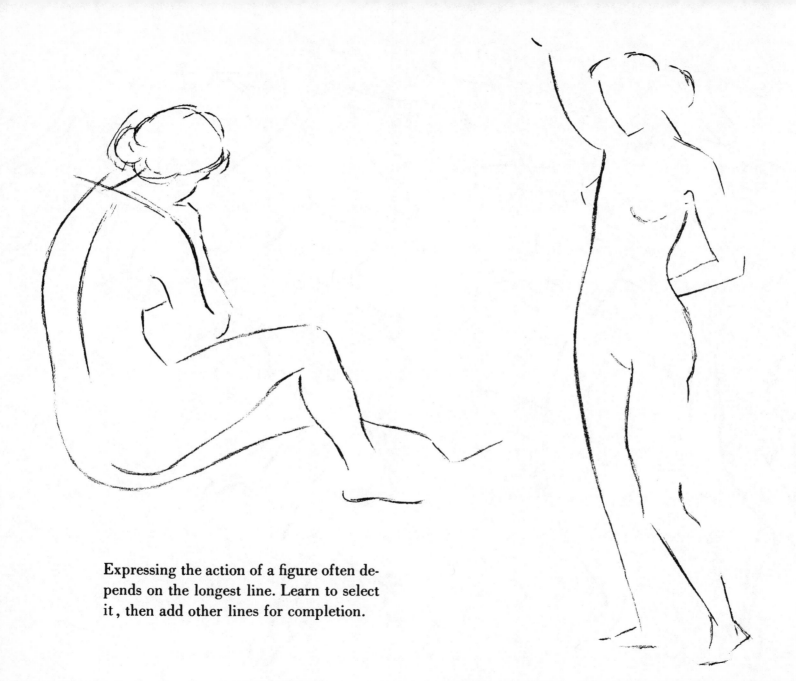

Expressing the action of a figure often de-
pends on the longest line. Learn to select
it , then add other lines for completion.

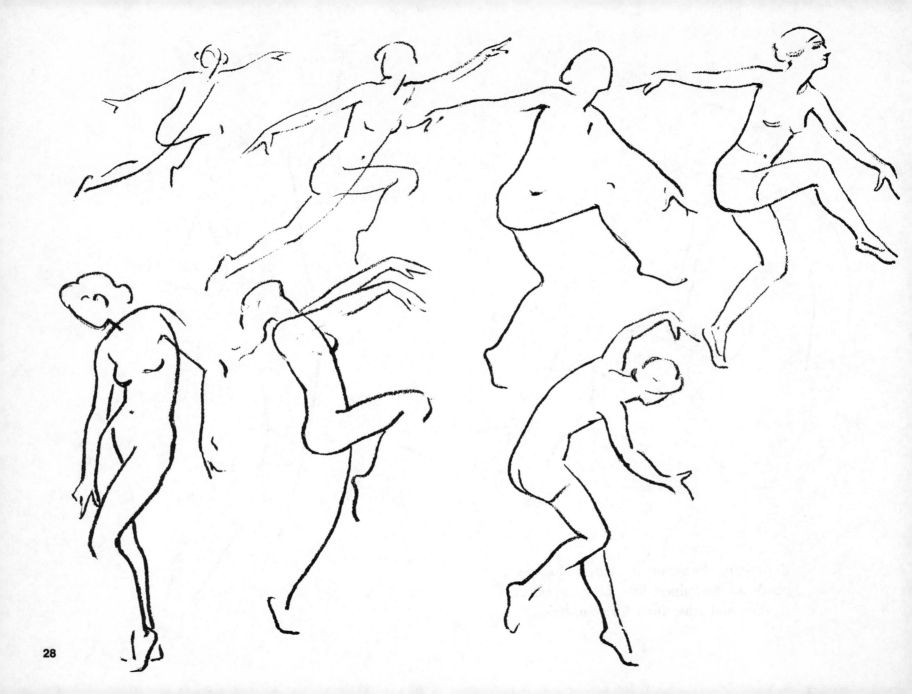

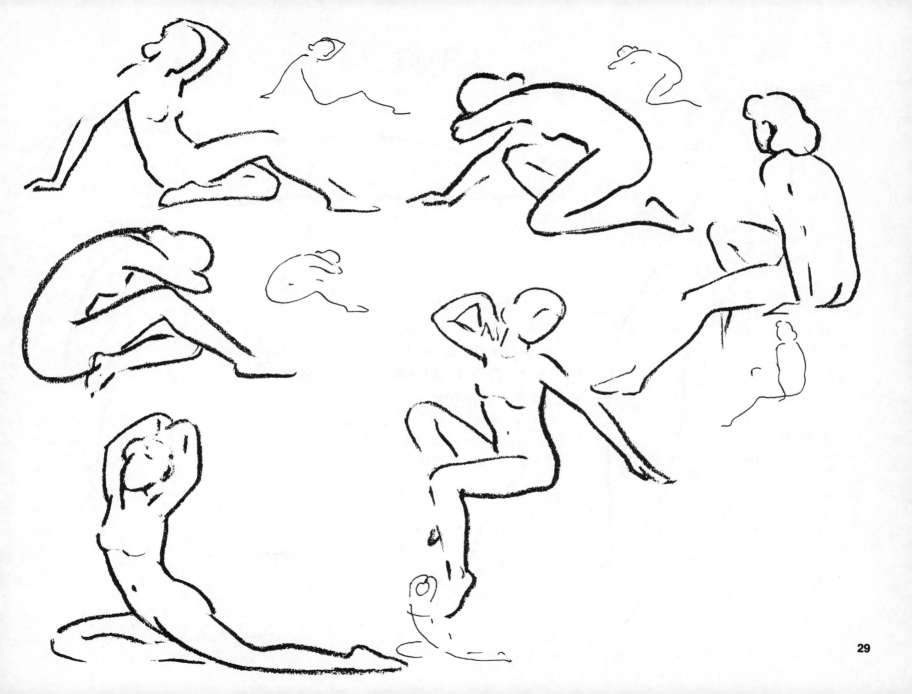

ARMS

Female

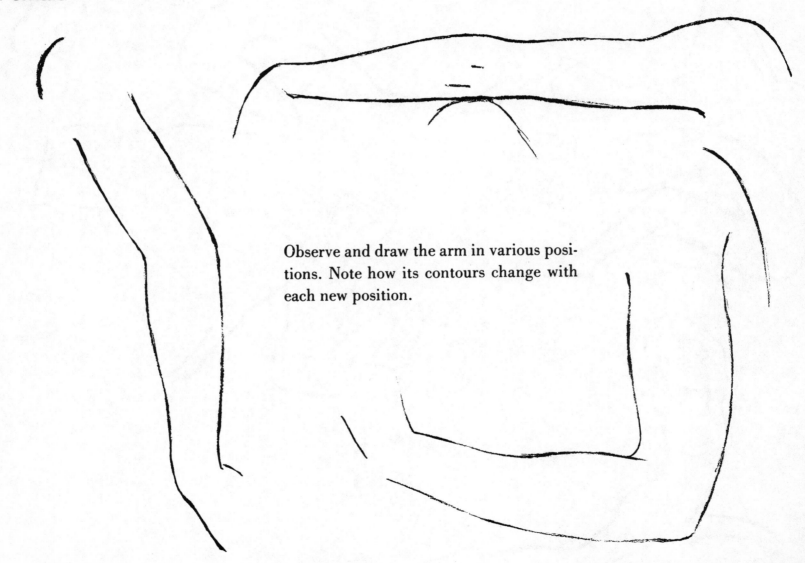

Observe and draw the arm in various positions. Note how its contours change with each new position.

HANDS

Female

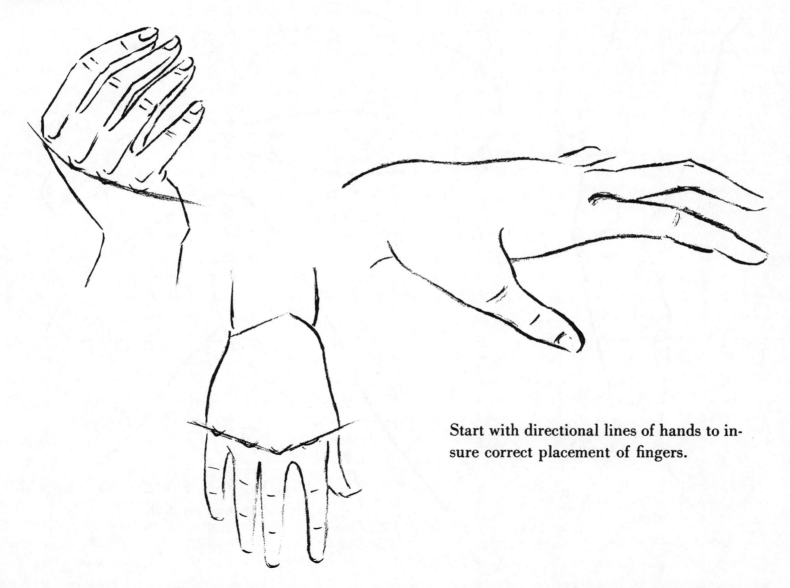

Start with directional lines of hands to in-
sure correct placement of fingers.

LEGS

Female

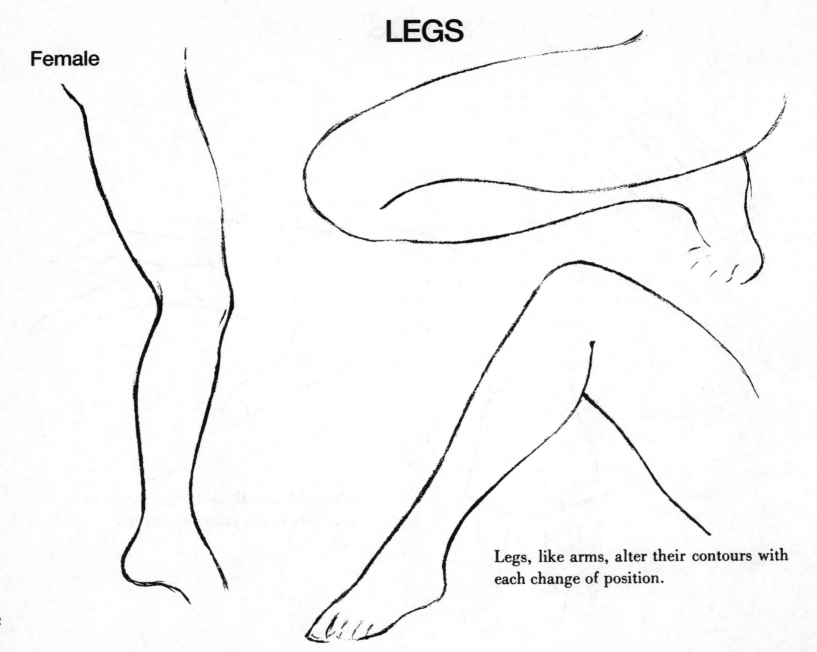

Legs, like arms, alter their contours with each change of position.

Female

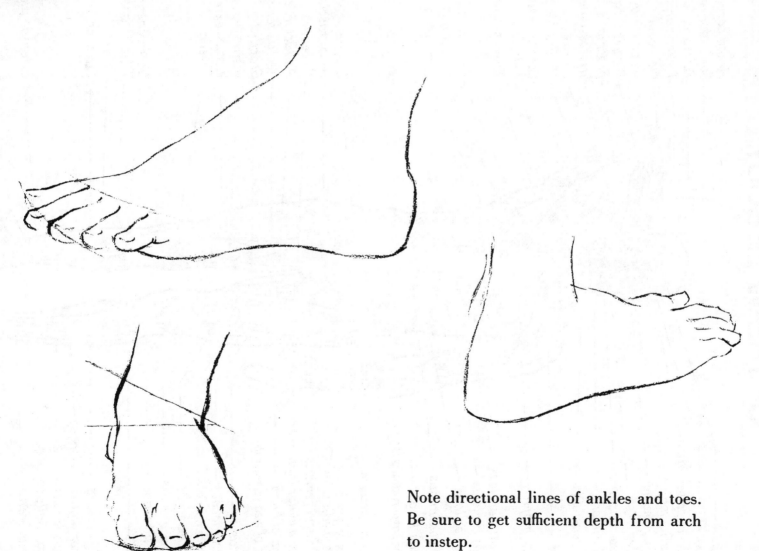

Note directional lines of ankles and toes.
Be sure to get sufficient depth from arch
to instep.

33

MUSCULAR CONSTRUCTION
OF THE MALE BODY

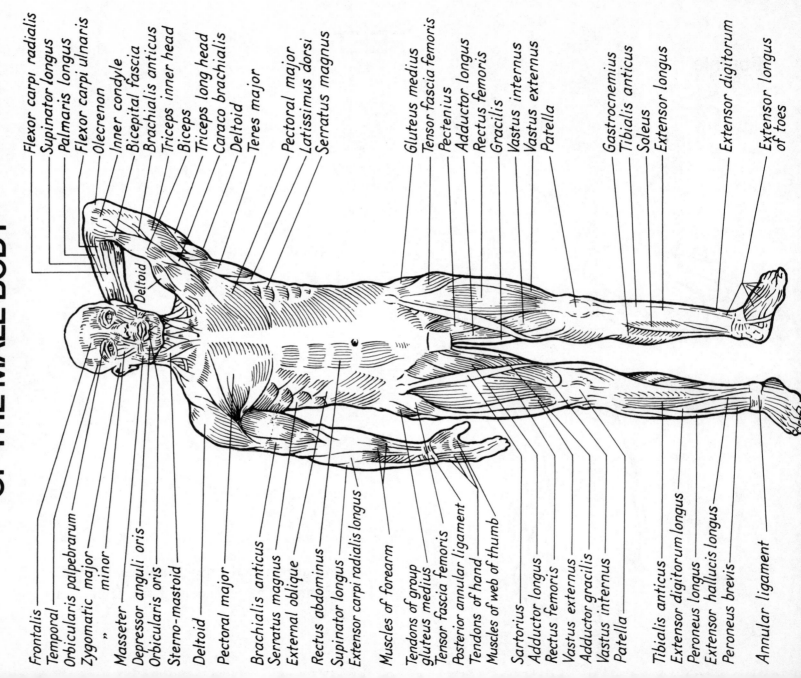

Flexor carpi radialis
Supinator longus
Palmaris longus
Flexor carpi ulnaris
Olecrenon
Inner condyle
Bicepital fascia
Brachialis anticus
Triceps inner head
Biceps
Triceps long head
Caraco brachialis
Deltoid
Teres major

Pectoral major
Latissimus dorsi
Serratus magnus

Gluteus medius
Tensor fascia femoris
Pectenius
Adductor longus
Rectus femoris
Gracilis
Vastus internus
Vastus externus
Patella

Gastrocnemius
Tibialis anticus
Soleus
Extensor longus

Extensor digitorum

Extensor longus
of toes

Deltoid

Frontalis
Temporal
Orbicularis palpebrarum
Zygomatic major
,, minor

Masseter
Depressor anguli oris
Orbicularis oris
Sterno-mastoid

Deltoid

Pectoral major

Brachialis anticus
Serratus magnus
External oblique

Rectus abdominus

Supinator longus
Extensor carpi radialis longus

Muscles of forearm

Tendons of group
gluteus medius
Tensor fascia femoris
Posterior annular ligament
Tendons of hand
Muscles of web of thumb

Sartorius
Adductor longus
Rectus femoris
Vastus externus
Adductor gracilis
Vastus internus
Patella

Tibialis anticus
Extensor digitorum longus
Peroneus longus
Extensor hallucis longus
Peroneus brevis

Annular ligament

34

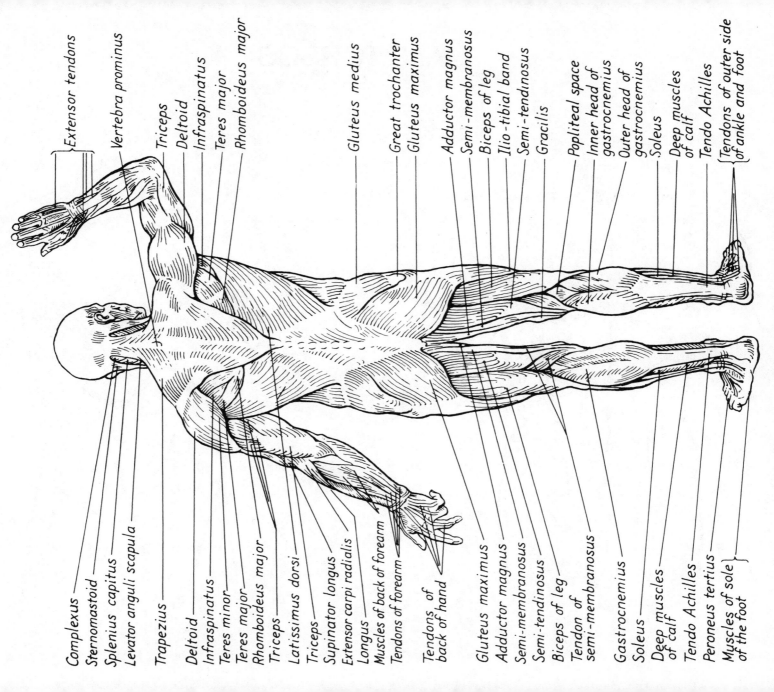

MUSCLES OF BODY (back view)

Top labels (left to right):
Extensor tendons
Vertebra prominus
Triceps
Deltoid
Infraspinatus
Teres major
Rhomboideus major
Gluteus medius
Great trochanter
Gluteus maximus
Adductor magnus
Semi-membranosus
Biceps of leg
Ilio-tibial band
Semi-tendinosus
Gracilis
Popliteal space
Inner head of gastrocnemius
Outer head of gastrocnemius
Soleus
Deep muscles of calf
Tendo Achilles
Tendons of outer side of ankle and foot

Bottom labels (left to right):
Complexus
Sternomastoid
Splenius capitus
Levator anguli scapula
Trapezius
Deltoid
Infraspinatus
Teres minor
Teres major
Rhomboideus major
Triceps
Latissimus dorsi
Triceps
Supinator longus
Extensor carpi radialis
Longus
Muscles of back of forearm
Tendons of forearm
Tendons of back of hand
Gluteus maximus
Adductor magnus
Semi-membranosus
Semi-tendinosus
Biceps of leg
Tendon of semi-membranosus
Gastrocnemius
Soleus
Deep muscles of calf
Tendo Achilles
Peroneus tertius
Muscles of sole of the foot

35

MALE TORSOS

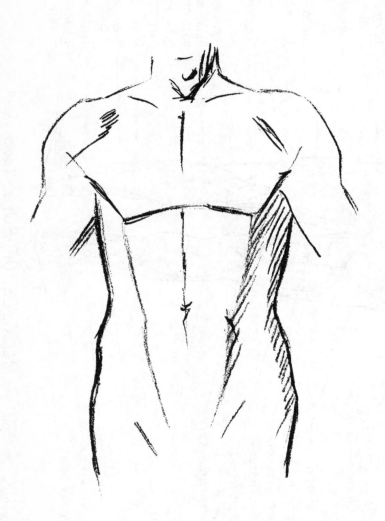

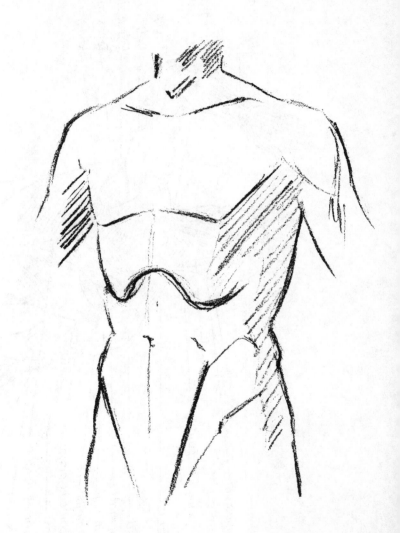

Male

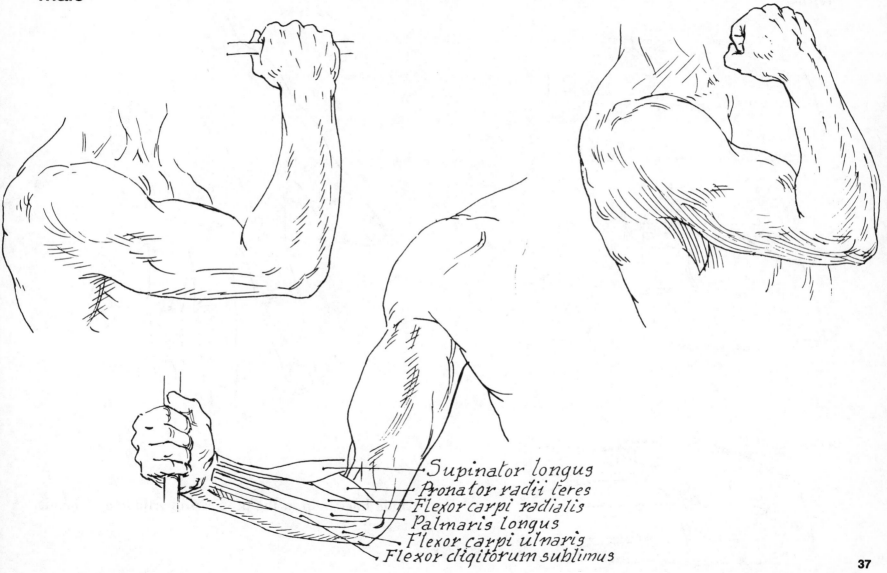

Supinator longus
Pronator radii teres
Flexor carpi radialis
Palmaris longus
Flexor carpi ulnaris
Flexor digitorum sublimus

HANDS

Male

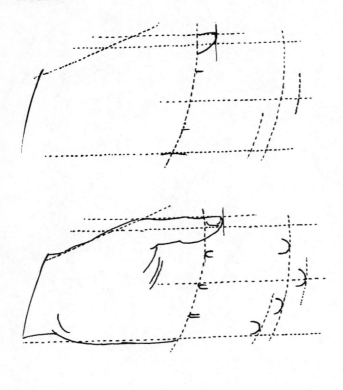

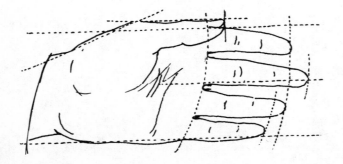

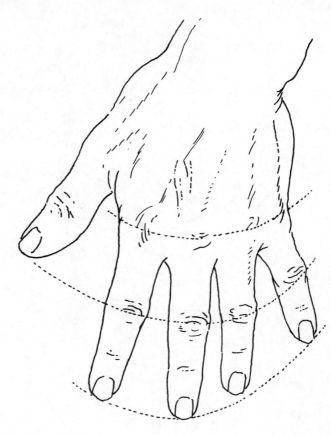

Guide lines help in the proper proportioning of hands.

FEET

Male

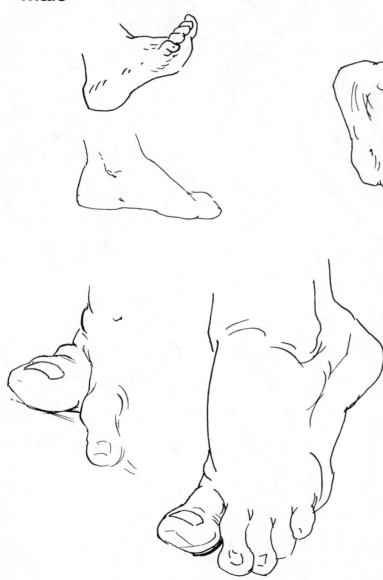

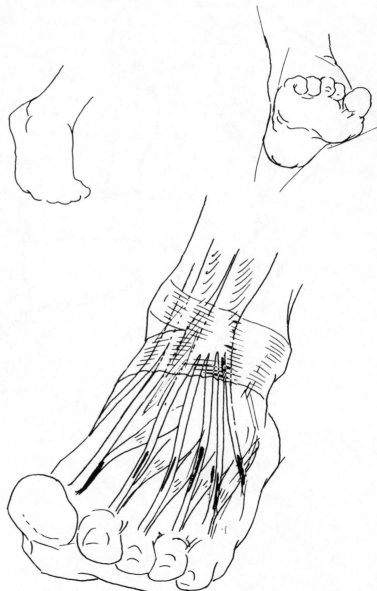

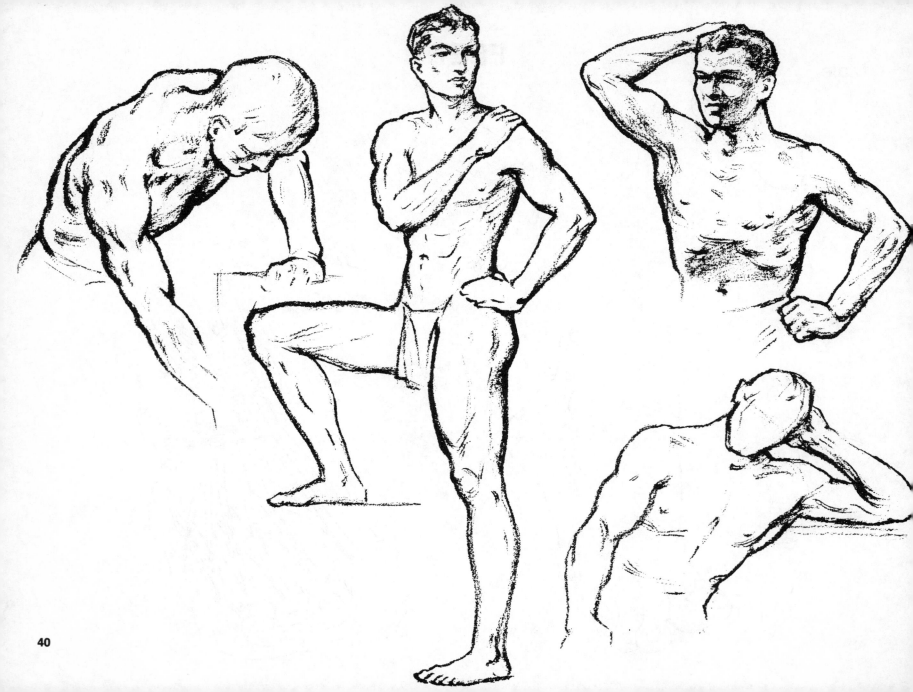

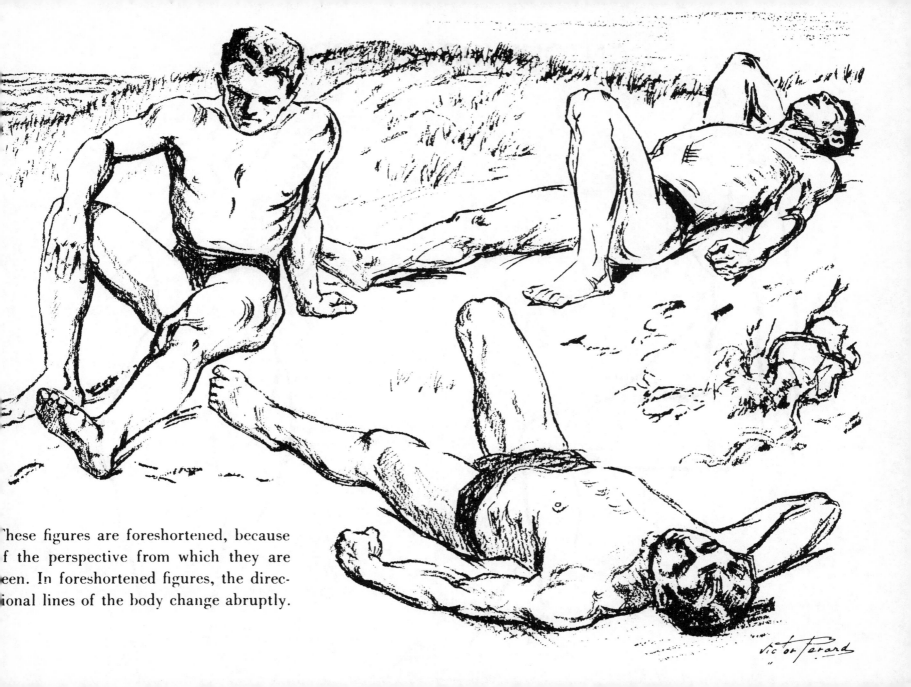

These figures are foreshortened, because
of the perspective from which they are
seen. In foreshortened figures, the direc-
tional lines of the body change abruptly.

CONTOUR (OR LINE) DRAWING

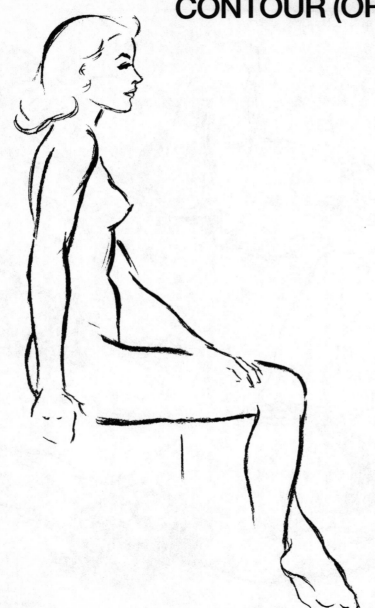

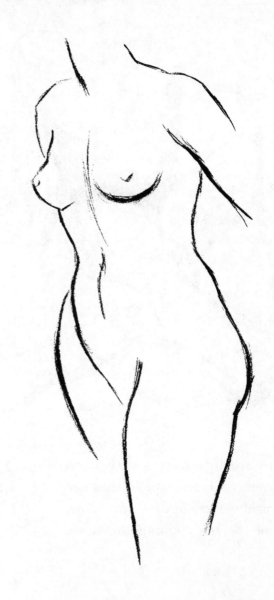

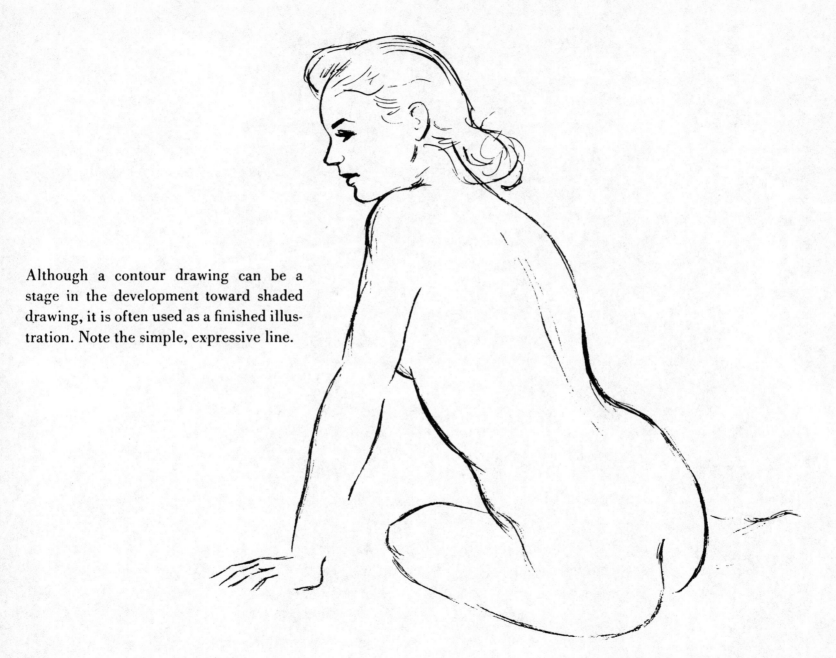

Although a contour drawing can be a stage in the development toward shaded drawing, it is often used as a finished illustration. Note the simple, expressive line.

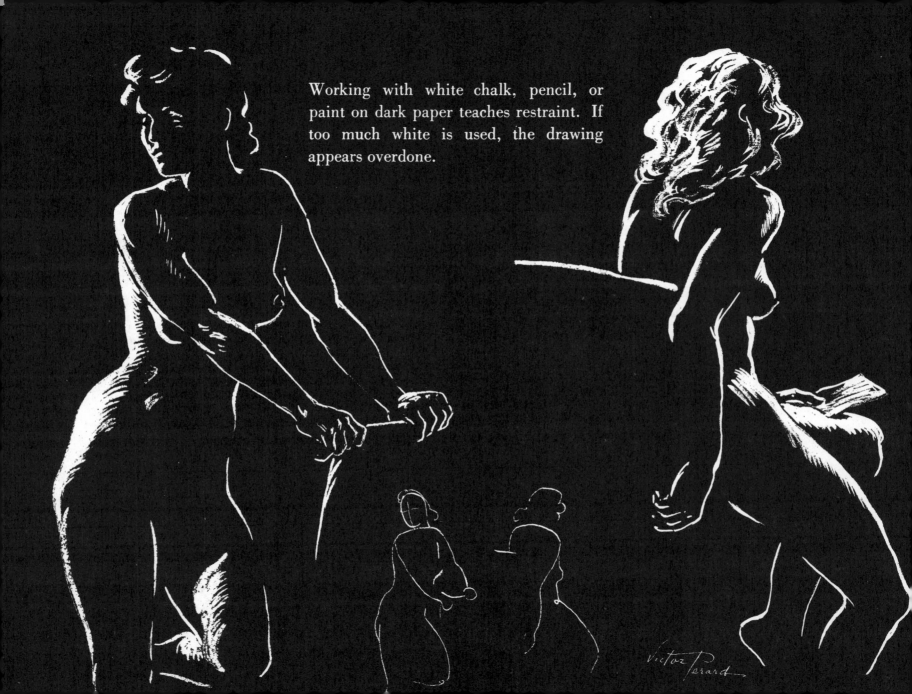

Working with white chalk, pencil, or
paint on dark paper teaches restraint. If
too much white is used, the drawing
appears overdone.

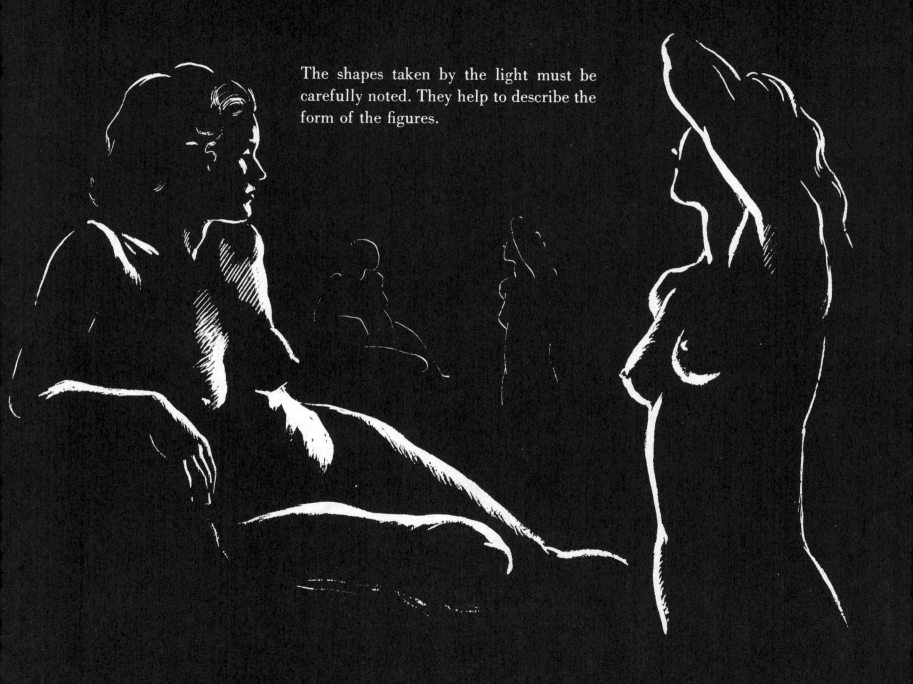

The shapes taken by the light must be carefully noted. They help to describe the form of the figures.

SHADING

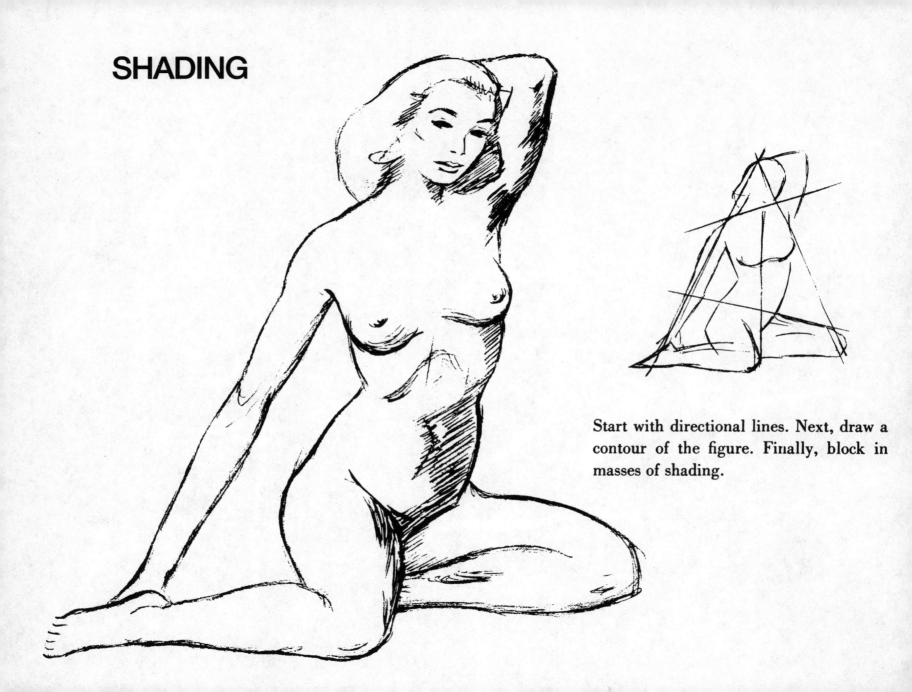

Start with directional lines. Next, draw a contour of the figure. Finally, block in masses of shading.

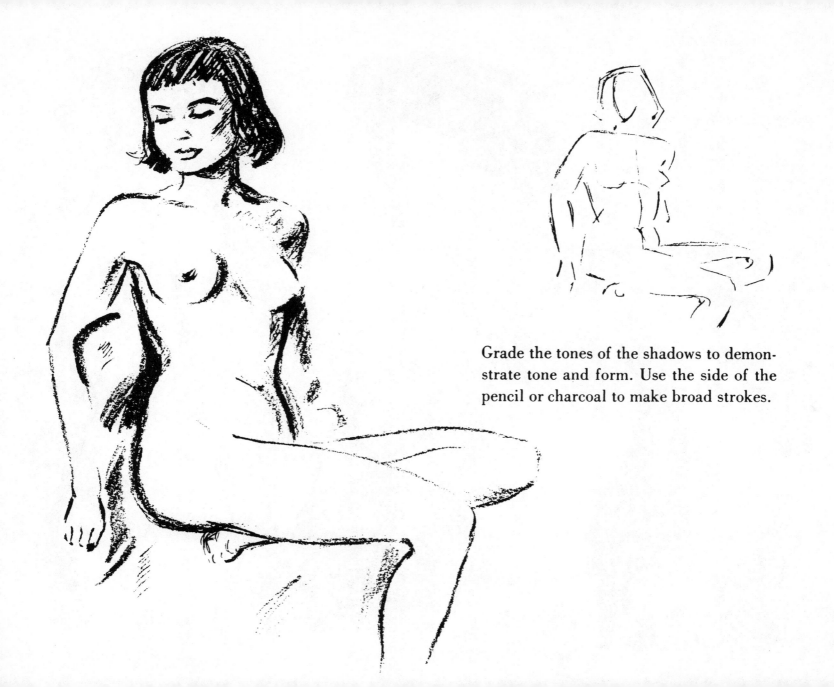

Grade the tones of the shadows to demonstrate tone and form. Use the side of the pencil or charcoal to make broad strokes.

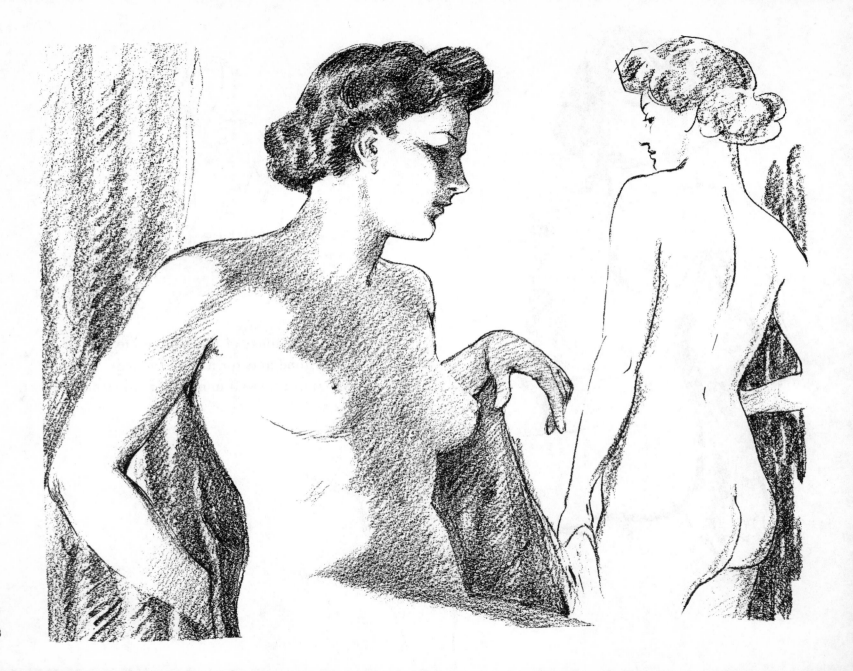

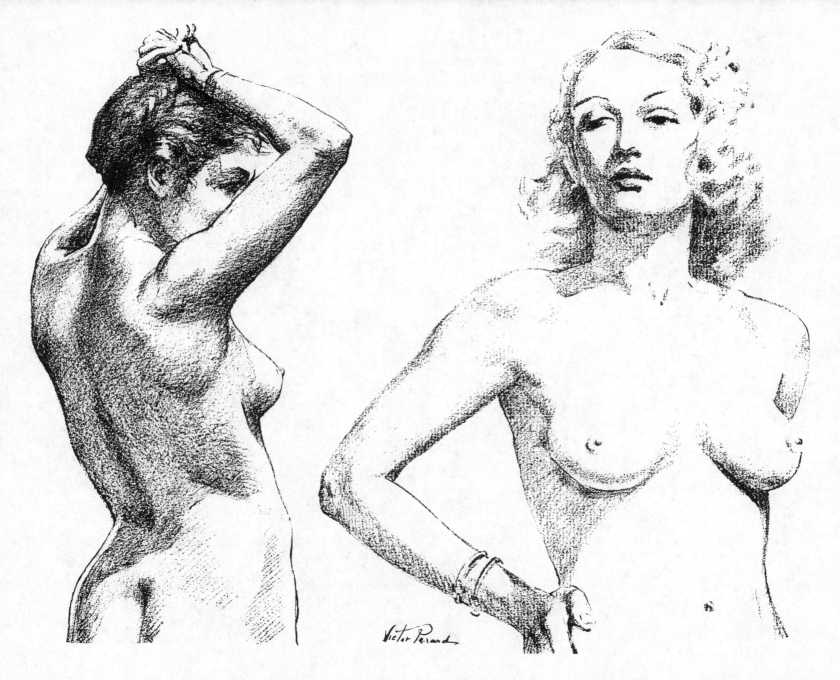

Victor Perard

49

GROUP FIGURES

Two or more figures drawn from the same
model can make an interesting grouping.

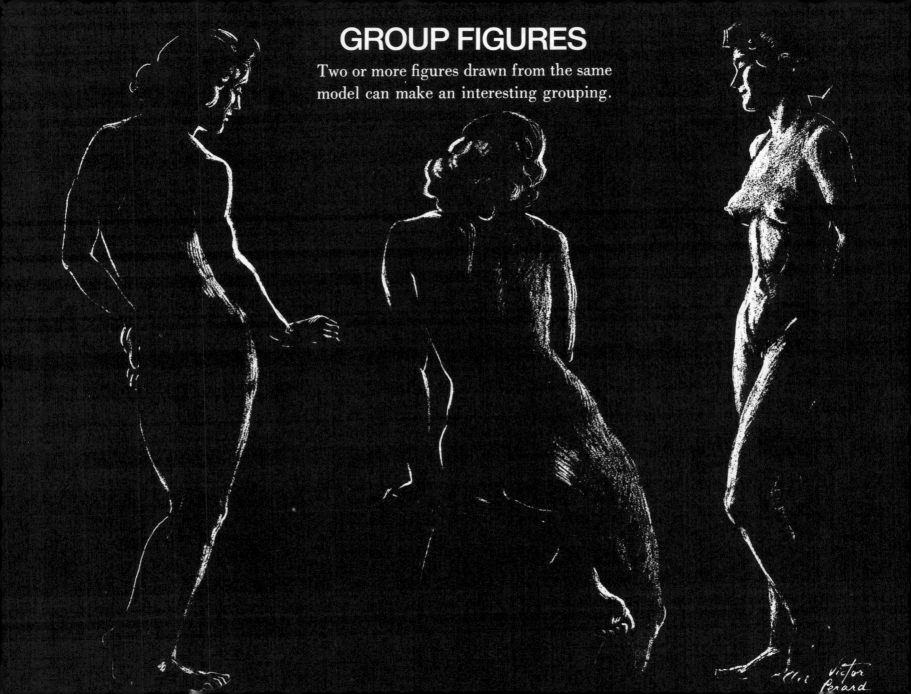

Victor
Perard

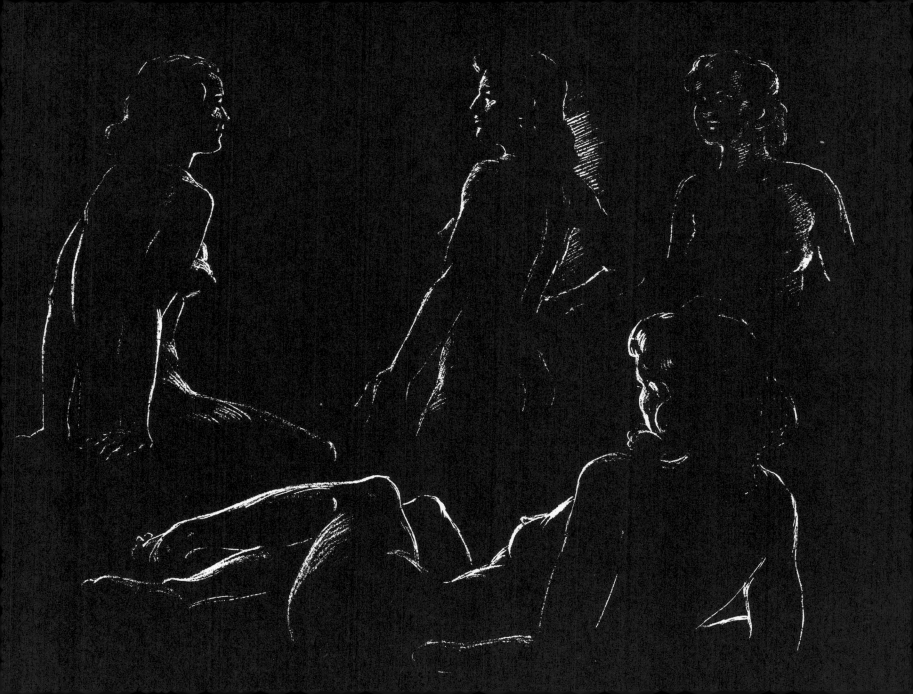

VARIED POSES

Lying-Down Pose

Copying figures in varied poses and from different angles is
good preparation for life studies.

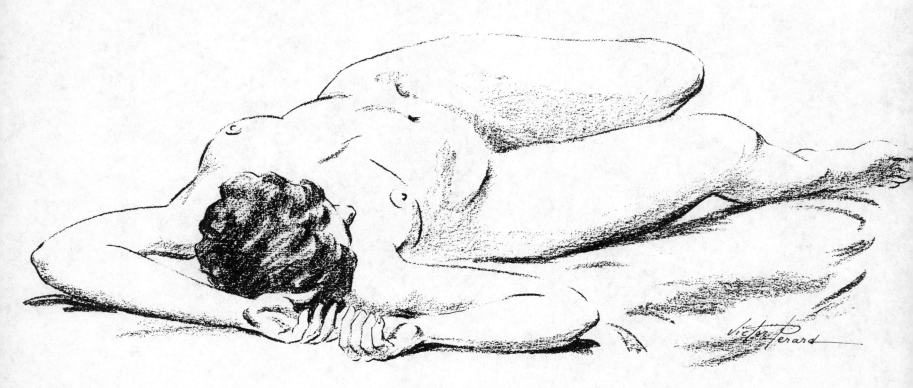

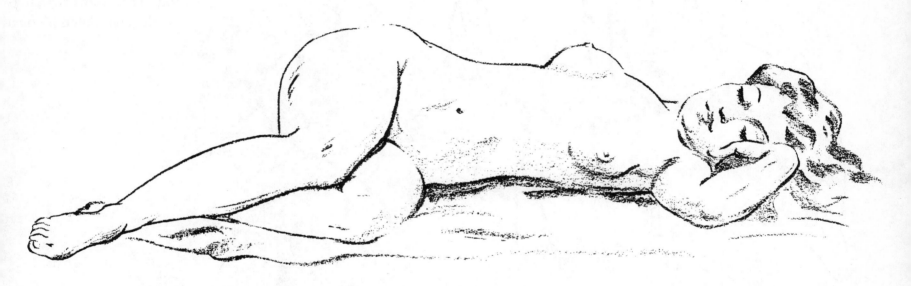

A lying-down pose calls for grace of line. One of the difficul-
ties of the pose is in judging proportions. Because the size of the
head is especially hard to determine, not much time should be
devoted to it until the rest of the figure is drawn. As a test of
accuracy, turn the paper around.

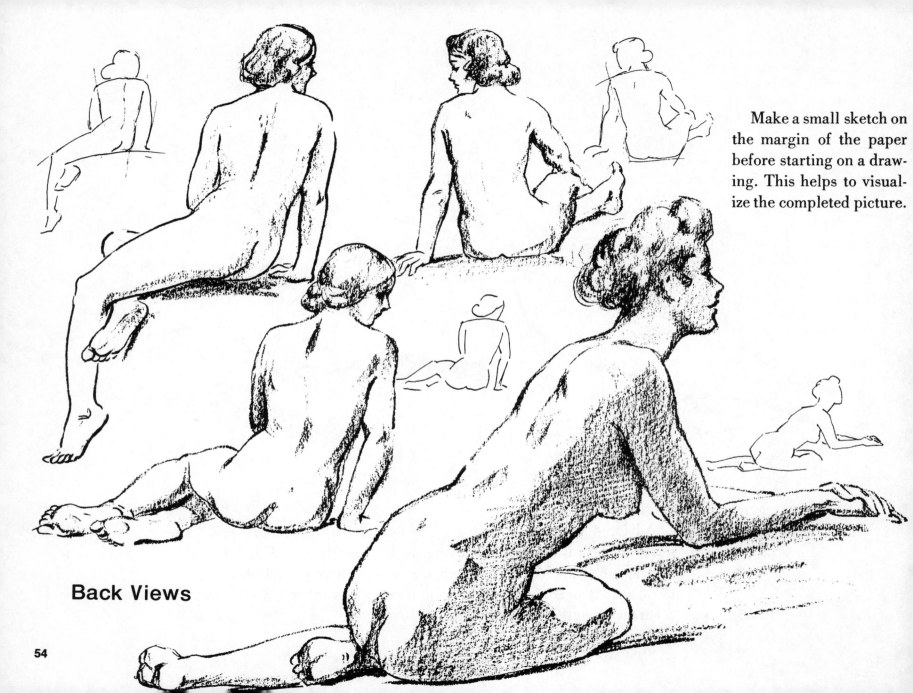

Make a small sketch on the margin of the paper before starting on a drawing. This helps to visualize the completed picture.

Back Views

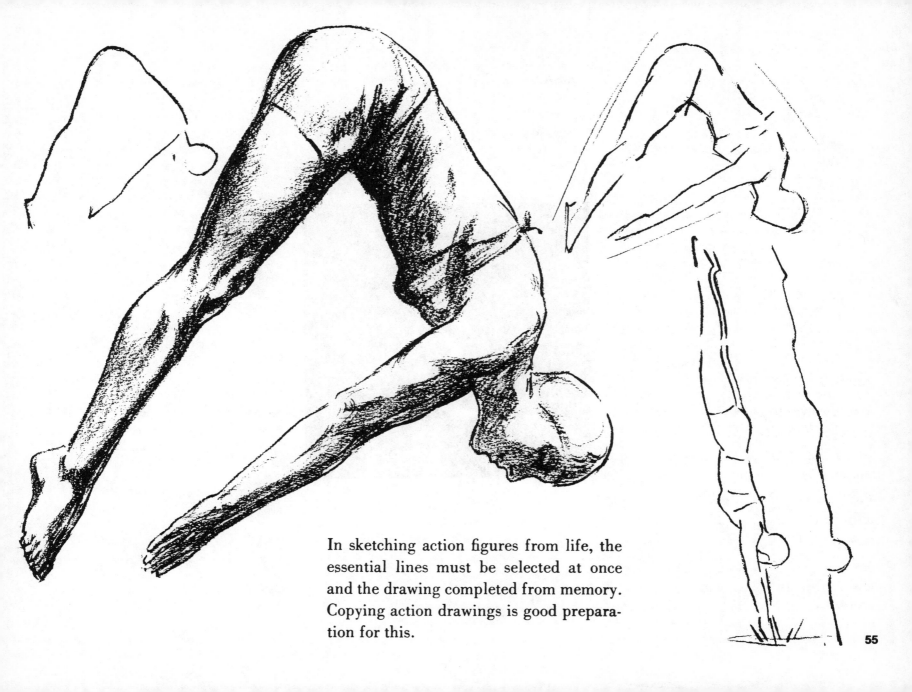

In sketching action figures from life, the
essential lines must be selected at once
and the drawing completed from memory.
Copying action drawings is good prepara-
tion for this.

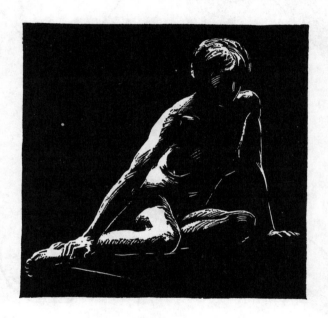

FACES AND EXPRESSIONS

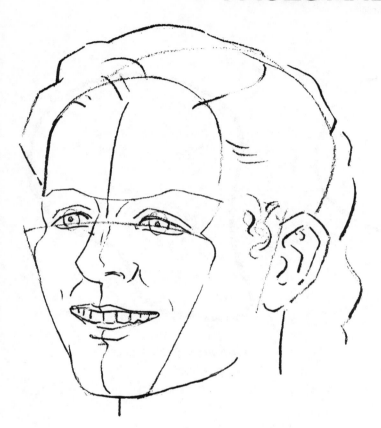

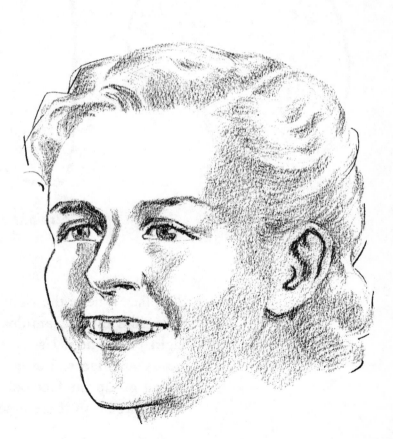

FACIAL SHAPES

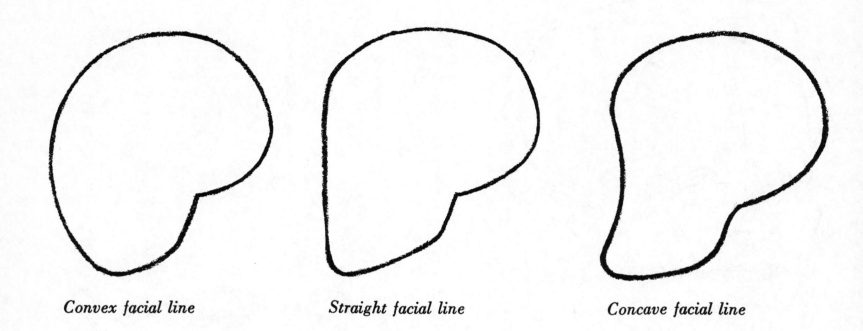

Convex facial line *Straight facial line* *Concave facial line*

To place a head the right size on a figure, keep it in simple form, like these examples without features until sure of the right proportion. Use this method in first layout of drawing heads and faces. For portraiture it is important to decide which group the face belongs to, the convex, straight, or concave. Sketch in these essential characteristics first.

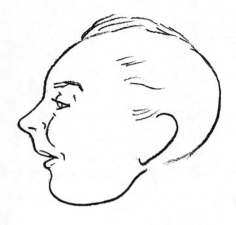

Convex face

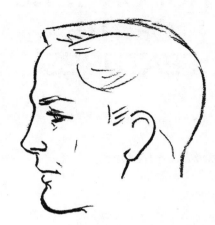

Straight face

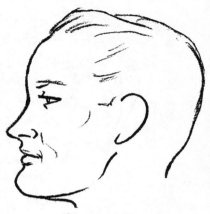

Concave face

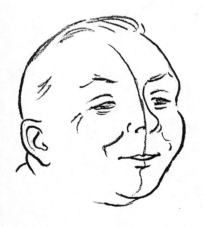

Three=quarter view

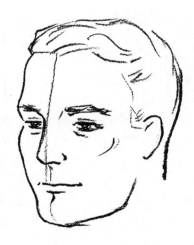

Three=quarter view

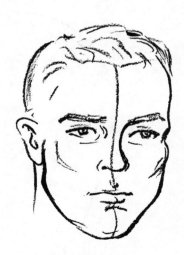

Front view

PROPORTIONS OF THE FEATURES

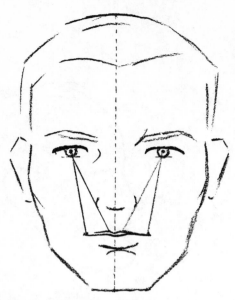

Broad angle face

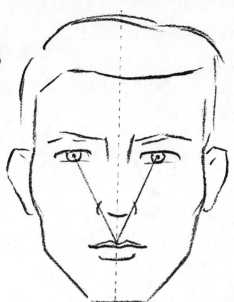

Narrow angle fa

Drop a line from the pupil of the eye to the corner of the mouth. Study the angle between the eyes and the mouth.

The distance between the eyebrows affects the appearance of the length of the nose.

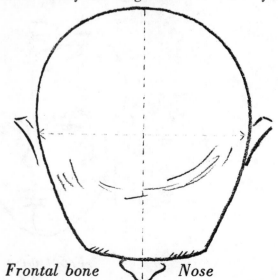

Frontal bone *Nose*

Ears are found at the widest part of the skull.

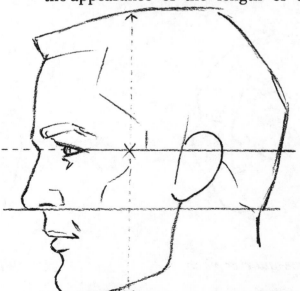

A line through the eyes marks the middle of the face.

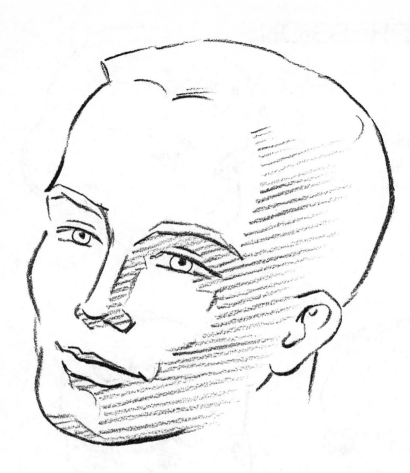

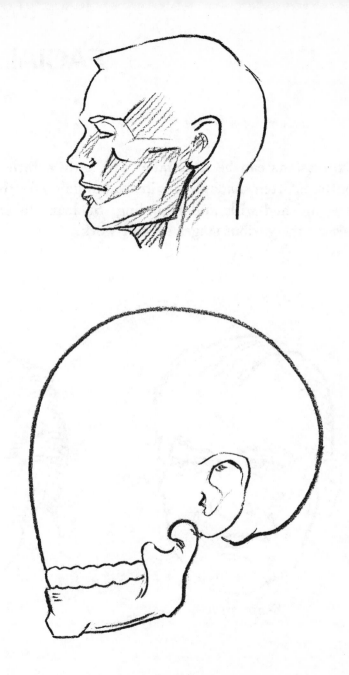

Use straight lines in blocking; they force attention to where lines change direction. Draw the facial line before adding the features.

Note the placing of the ear in relation to the jaw bone.

Form the habit of always blocking in the head.

FACIAL EXPRESSIONS

Expressions can be illustrated with only a little more than outline. Often shadows lose instead of gain effectiveness, unless finished with understanding. So learn to analyze and reason the various stages of your work.

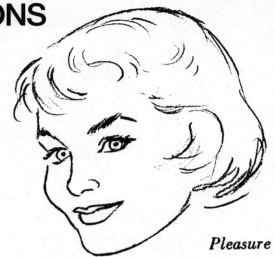

Pleasure

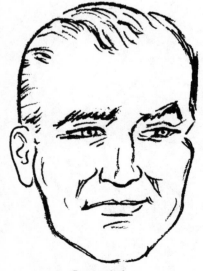

Scepticism

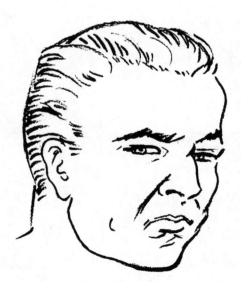

Disgust

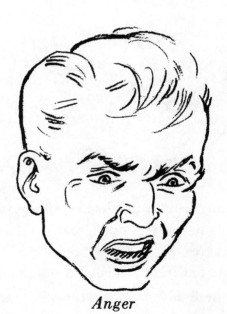

Anger

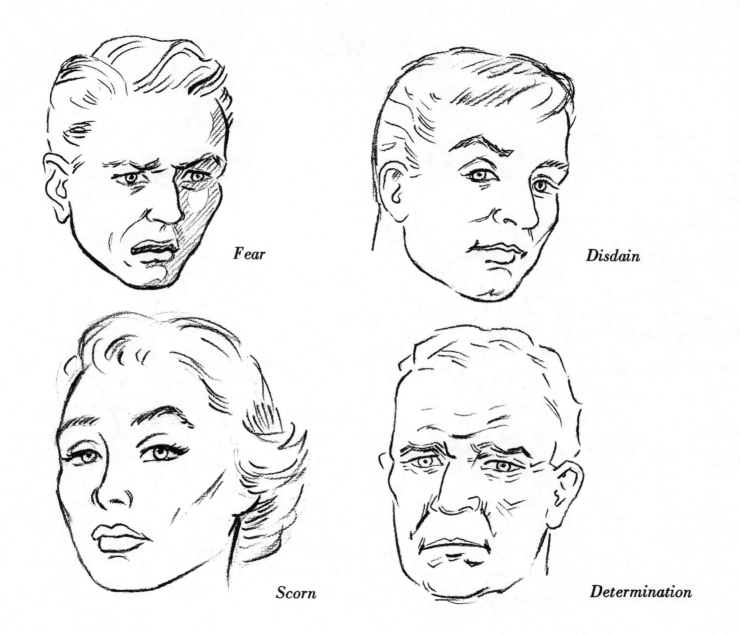

Fear

Disdain

Scorn

Determination

63

FEATURES

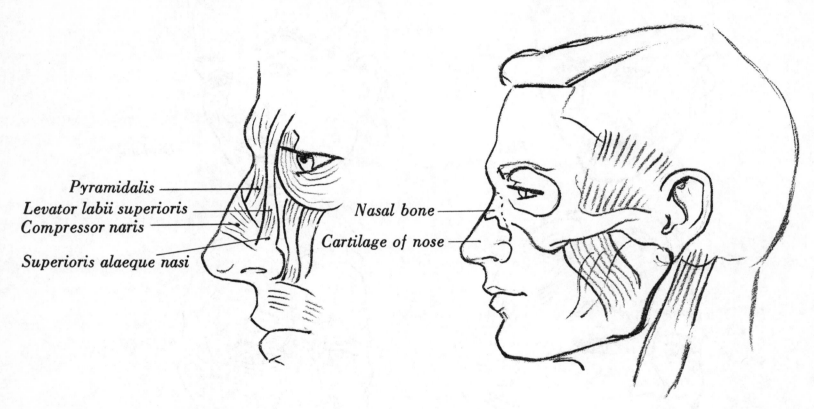

Pyramidalis ——————

Levator labii superioris ——————

Compressor naris ——————

Superioris alaeque nasi ——————

Nasal bone ——————

Cartilage of nose ——————

Nose

One of the important features for a likeness is the nose. It is composed of bone, muscle and cartilage.

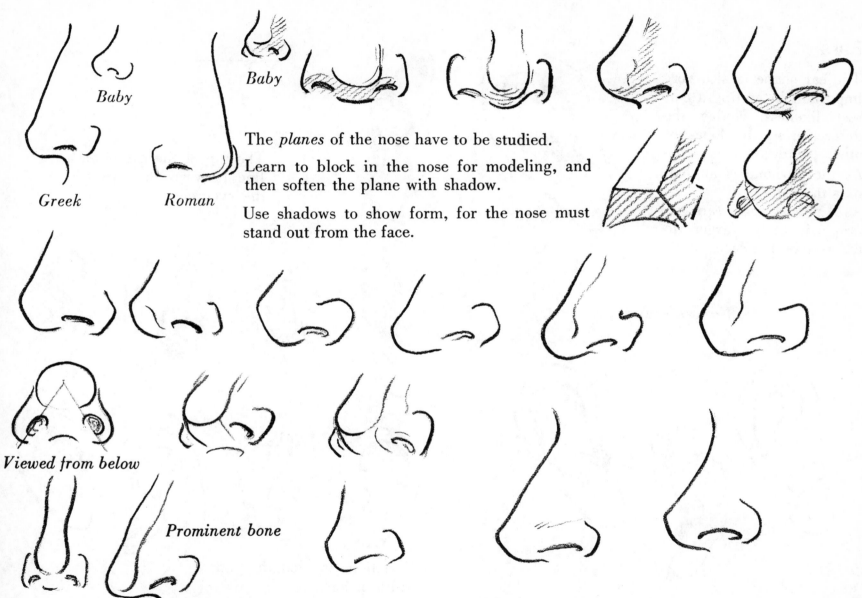

Baby

Greek

Roman

Baby

The *planes* of the nose have to be studied.

Learn to block in the nose for modeling, and then soften the plane with shadow.

Use shadows to show form, for the nose must stand out from the face.

Viewed from below

Prominent bone

Elevated nostril

Ears

The ear shape is also very important in getting a correct likeness. Notice the difference in the lobes of other people.

As the jawbone is angled, so is the ear.

As a person ages, ears get proportionately larger to the rest of the face.

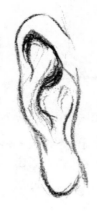

The top of the ear is on a line between the eye and the eyebrow.

Women's Ears

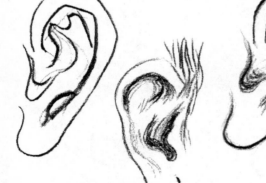

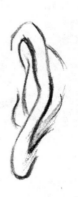
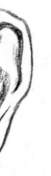
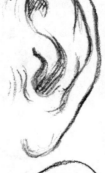
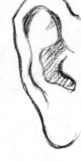

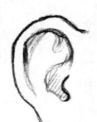

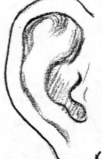

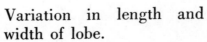

Variation in length and width of lobe.

Lips

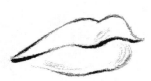

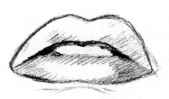

When drawing the front view of the lip bear in mind the profile contour.

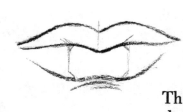

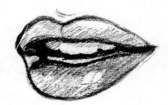

The lower lip is heavier than the upper and sets back.

The block shape of the lips should be kept in mind when shading. Suggest the teeth—do *not* over-emphasize.

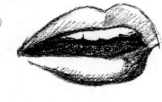

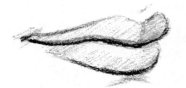

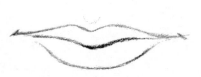

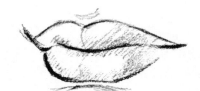

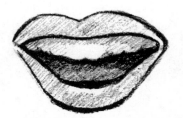

Eyes

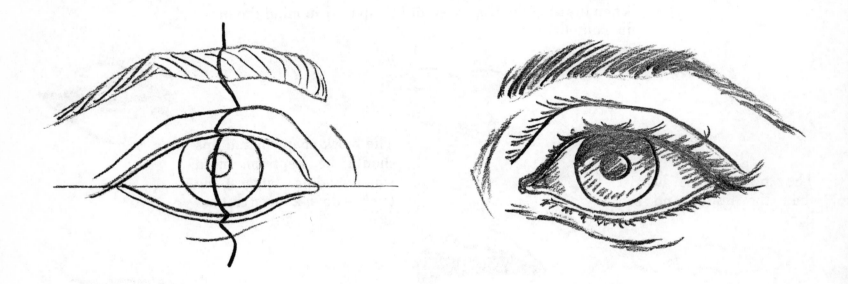

When drawing the front shape, remember profile contour lines.

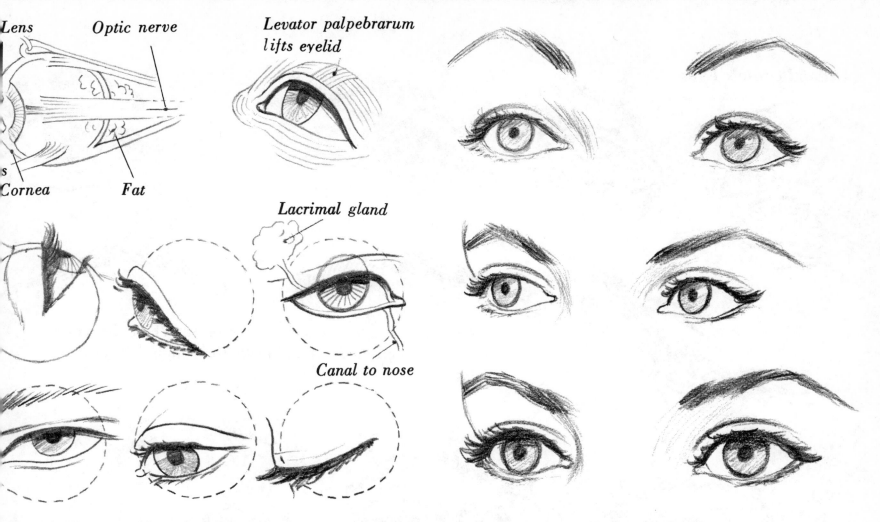

Lens Optic nerve

Levator palpebrarum
lifts eyelid

Cornea Fat

Lacrimal gland

Canal to nose

drawing eyes bear in mind to give the feeling of the sphere-
e form of the eyeball. Most eyeballs are about an inch in
ameter. Large eyes have a larger opening and in small eyes
e lids are closer together. The upper lid is heavier than
e lower lid. The amount of fat behind the eye accounts for
e sunken or bulging eye. It is a most delicate lubricating
fat and the first fat consumed in fever or exhaustion. The
lacrimal gland furnishes the moisture to clean and keep the
eye brilliant. The moisture is taken up by a small opening
which connects with the nose. The eyes depend on the lids
and muscles surrounding the eye for expression of emotions
of mirth, surprise, fear, scorn, hatred etc.

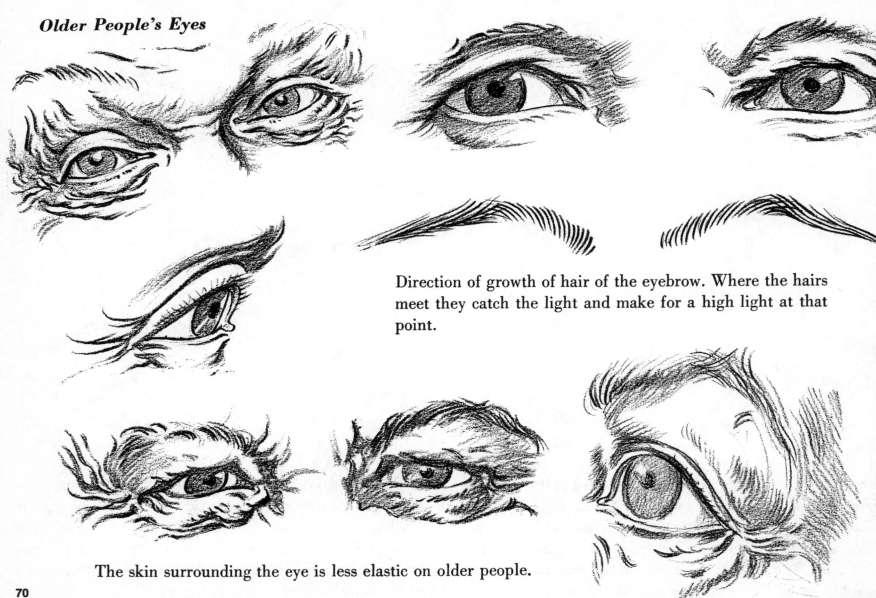

Older People's Eyes

Direction of growth of hair of the eyebrow. Where the hairs meet they catch the light and make for a high light at that point.

The skin surrounding the eye is less elastic on older people.

Hair

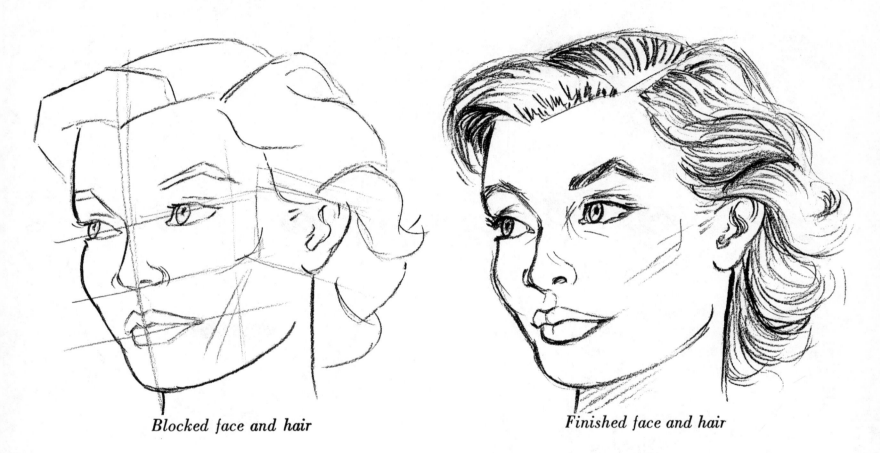

Blocked face and hair

Finished face and hair

Keep in mind the fact that hair has a definite shape; when blocked it is greatly affected by light and shade. Avoid making hair appear like straw. Hair always has form.

HEADS TO DRAW

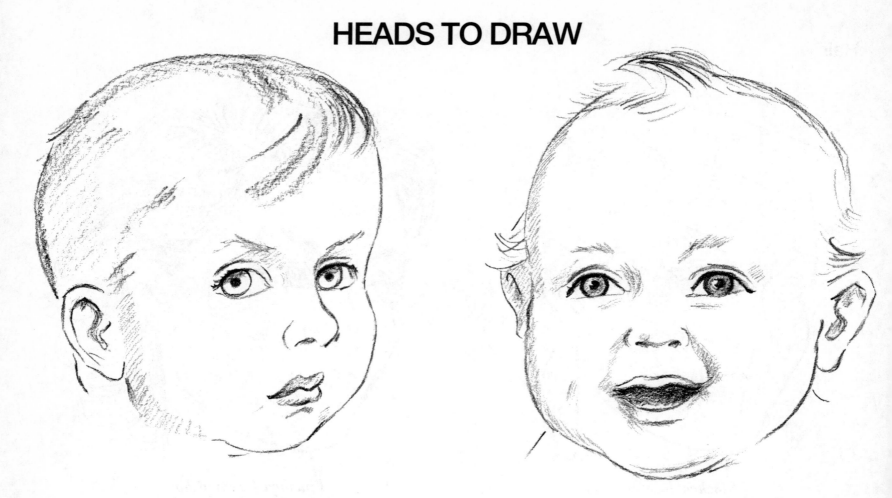

Babies

In drawing babies note that the skull is larger than the face. The back of the neck is usually straight as the spine is straight and does not reach the S-shape curves until walking in the erect position has been practiced for some time.

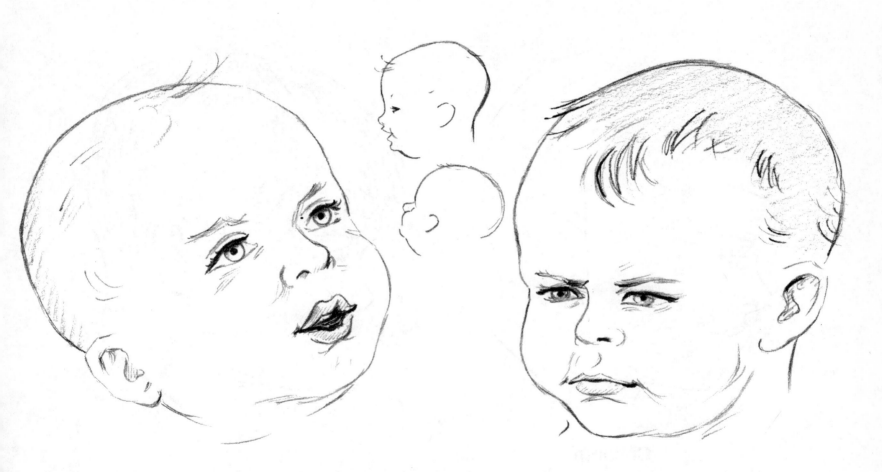

Draw your ovals lightly with the medium hard pencil. Place the facial line down the front of the face, also the eye and mouth lines. Then begin to draw the expressions with your softer pencil.

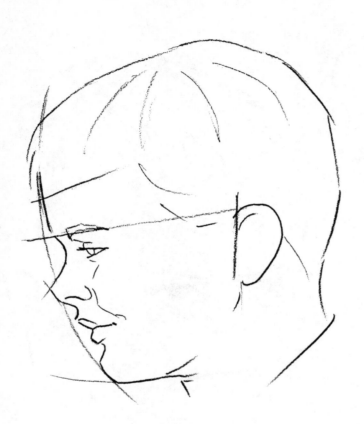

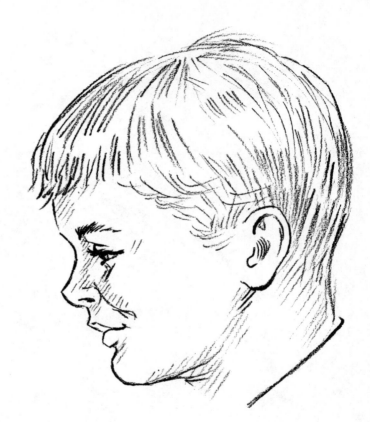

Children

Draw the heads as large as possible; this will prevent falling into a cramped style. Lay in the preliminary lines simply and with conviction. When the outline is finished, it will take surprisingly little to complete the drawing.

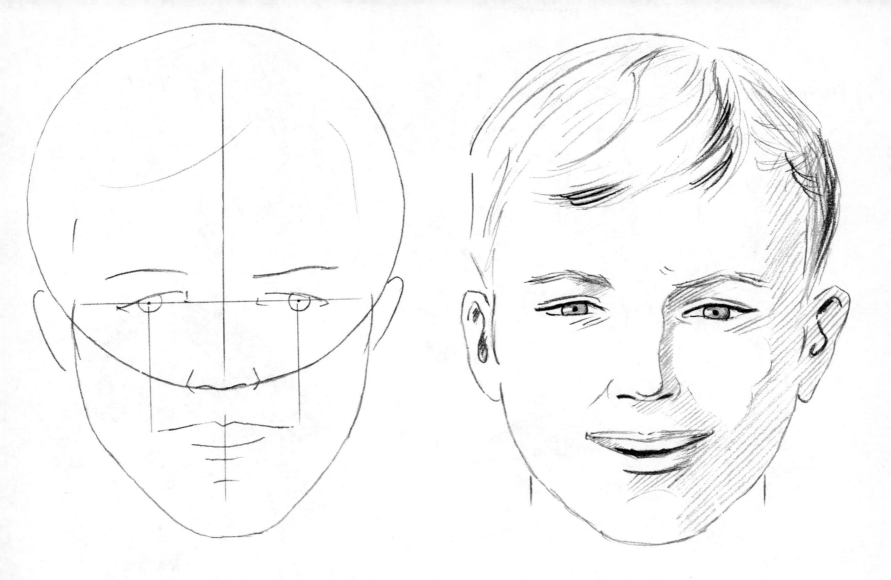

In drawing heads always decide on the size of the skull in relation to the face. The likeness of the shape of the head should be striven for before placing the features on the face.

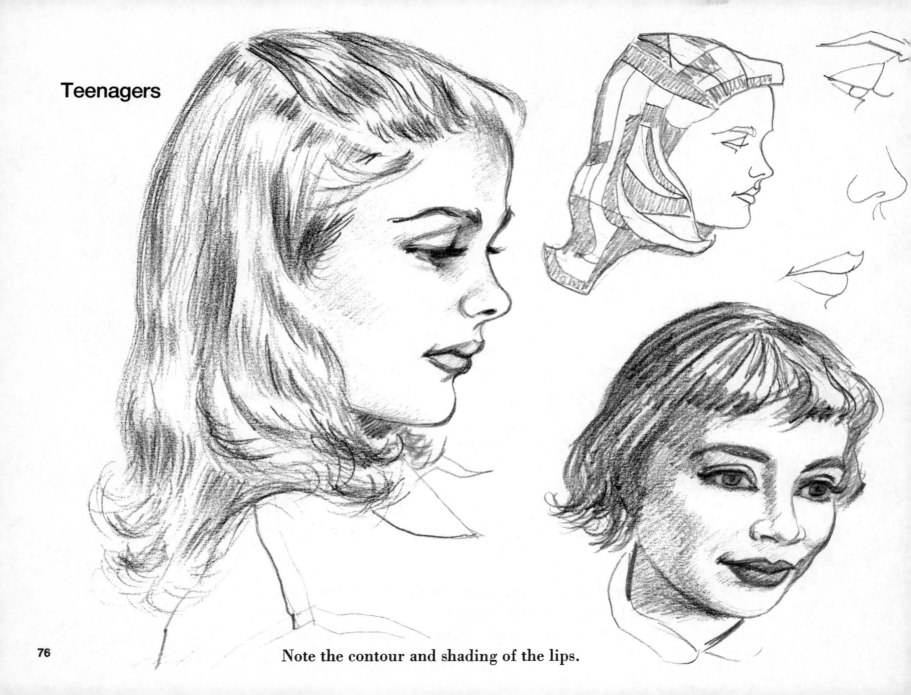

Teenagers

Note the contour and shading of the lips.

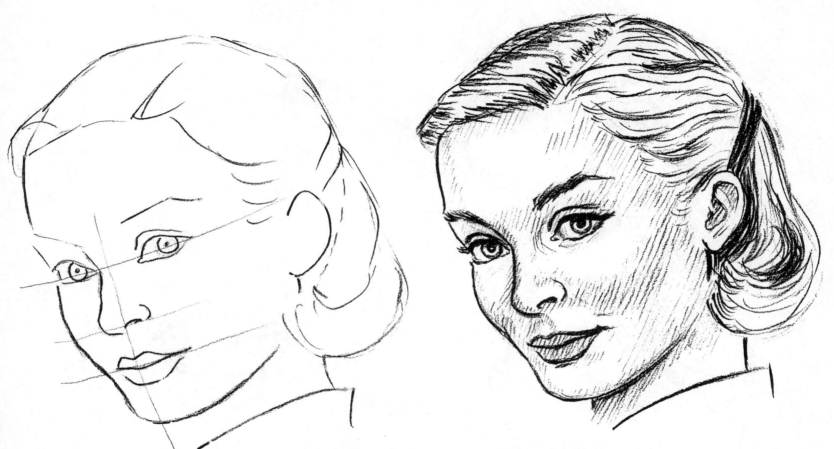

Use the framework of lines to keep the two studies of the face in proper relation. The line running through the eyes guards against getting the eye too high or too low. The facial line running down the face is always a help in molding the front of the face and in drawing the nose in the correct place.

Women

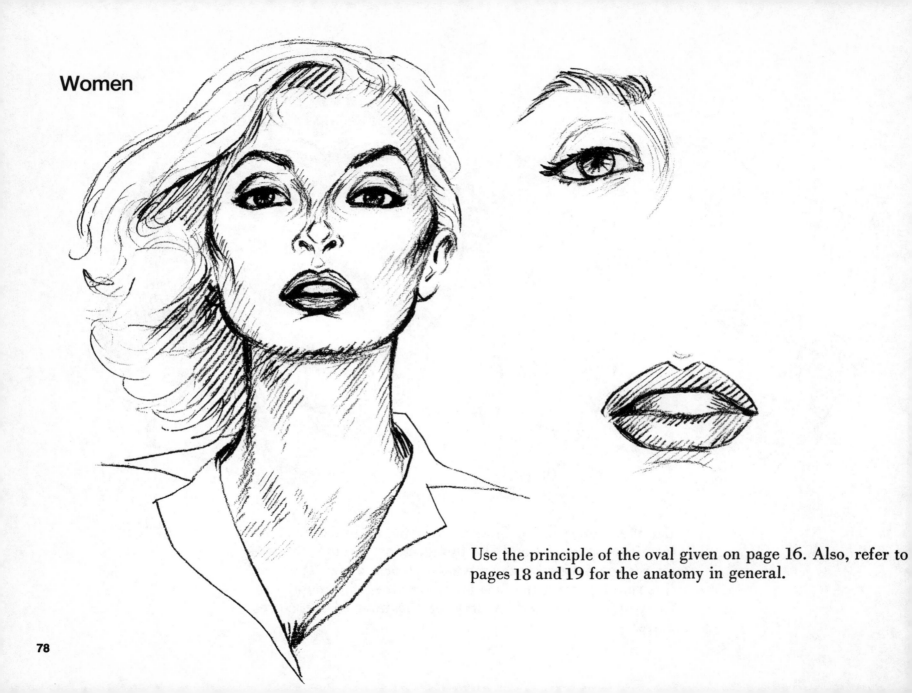

Use the principle of the oval given on page 16. Also, refer to pages 18 and 19 for the anatomy in general.

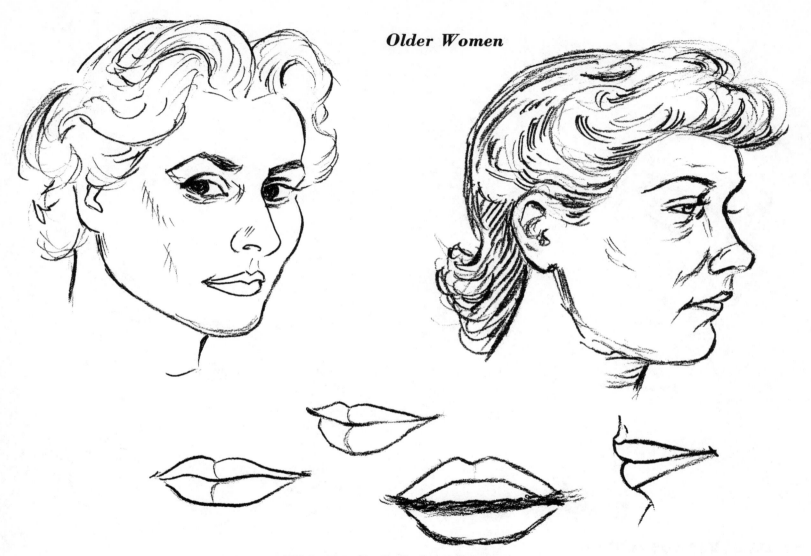

With age, lines and wrinkles appear.

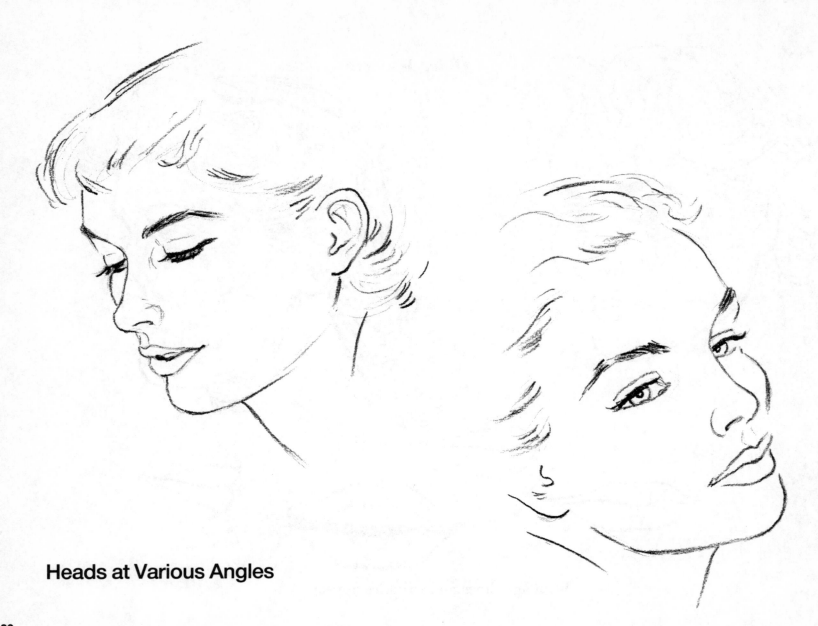

Heads at Various Angles

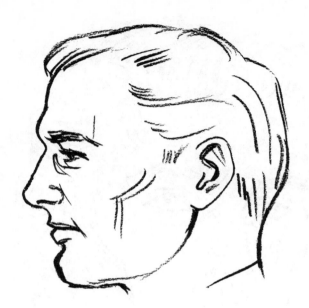 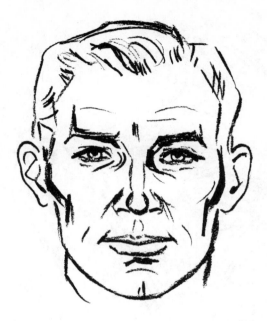

The lines of a man's face have much sharper angles.

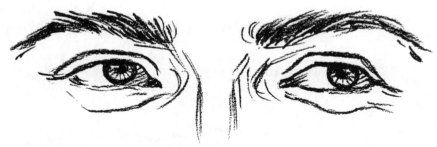

Eyebrows straighten and *seem* much closer together than on a woman.

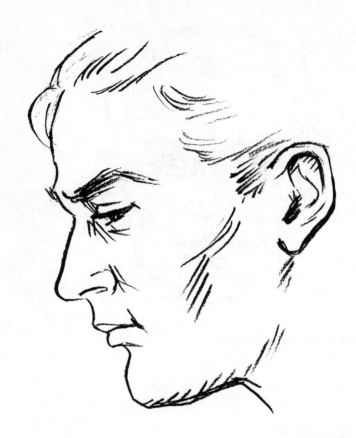

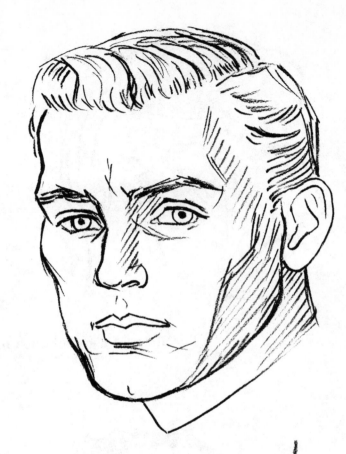

Note the lip contour.

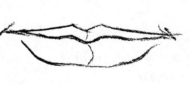

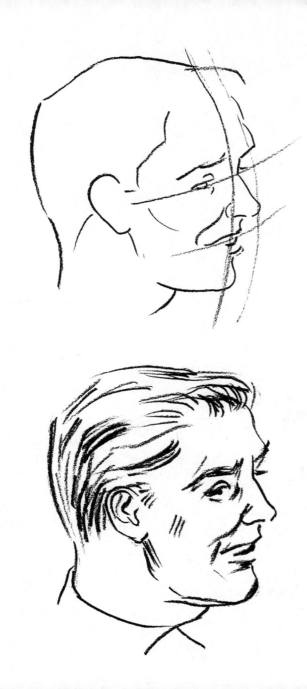

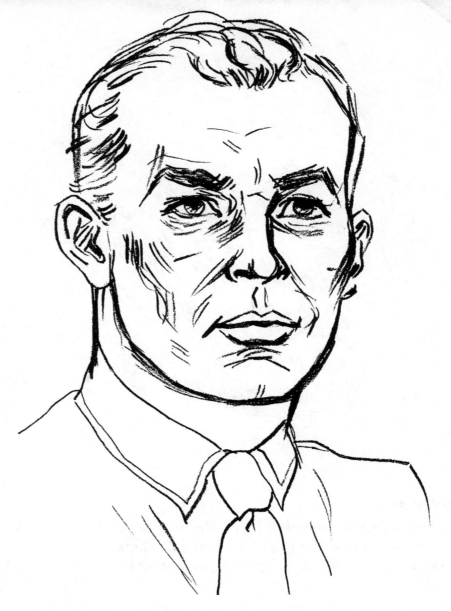

Attempt to draw heads similar to this one from those which
you see around you everyday.

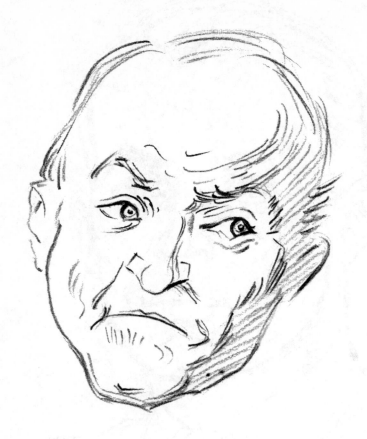

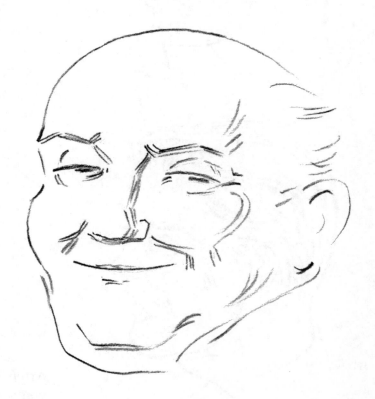

Older Men

Note the wrinkles around the eyes. Begin to draw the expression in softer pencil or charcoal. These lines should be drawn using the pencil boldly.

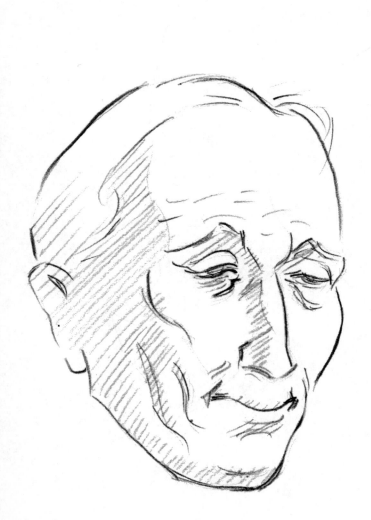

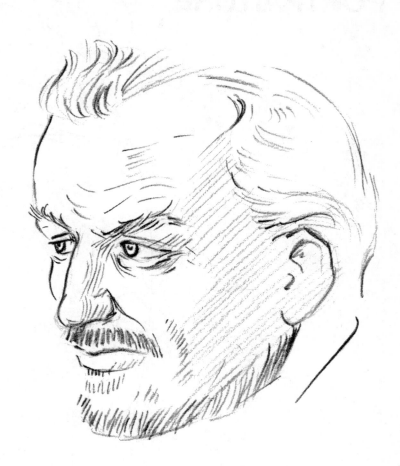

PORTRAITURE

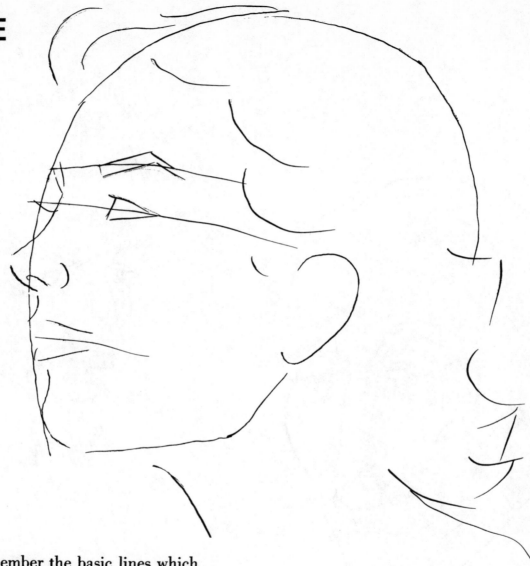

In using the next four pages remember the basic lines which
have been stressed previously in this book. Keep a sweep in
your drawing.

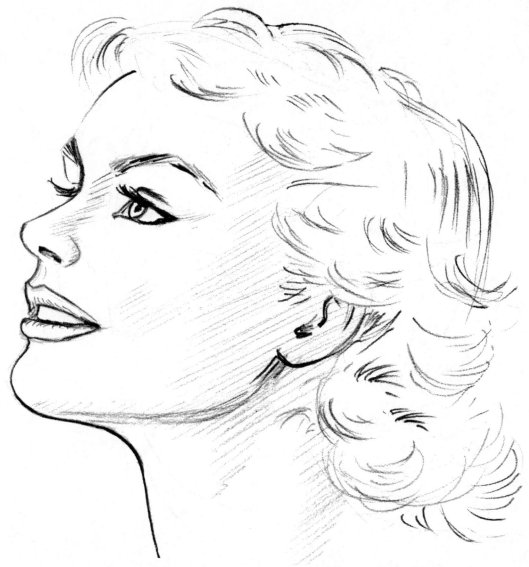

Remember the blocking of the hair, the shading of the planes of the features, and the contours of the eyes and lips.

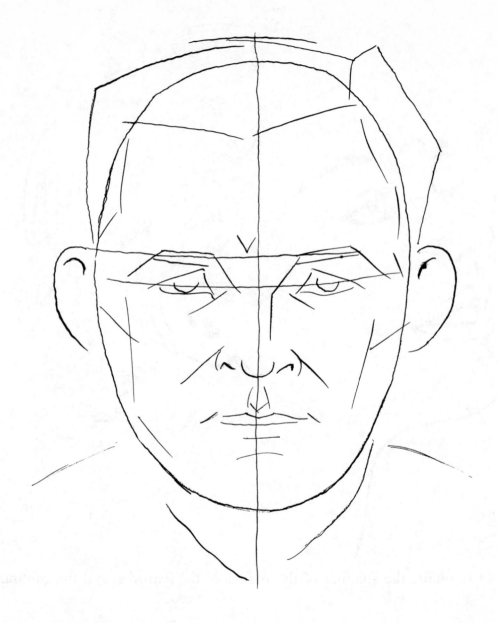

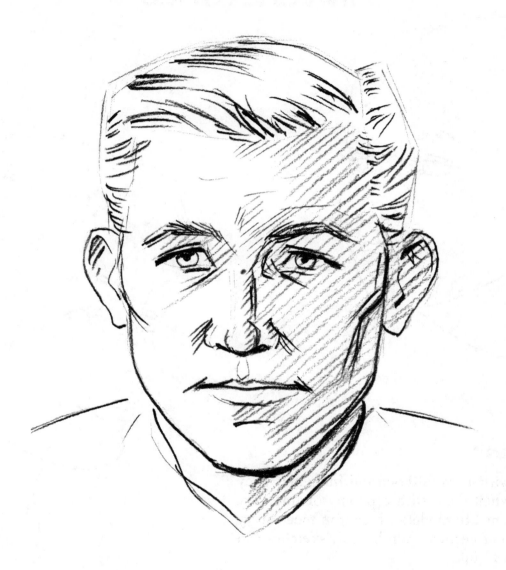

INK SKETCHES

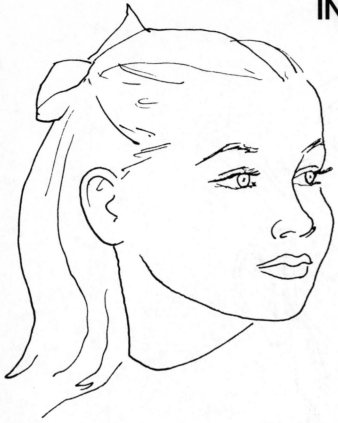

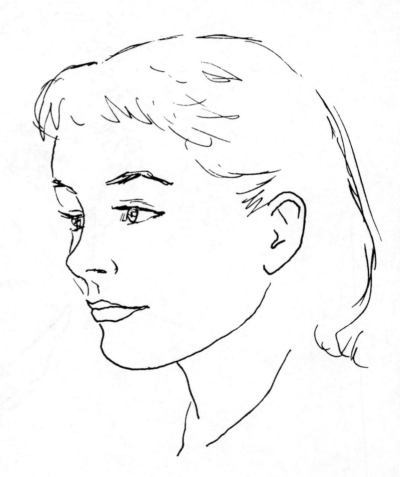

Quick Ink Sketches

These are drawn here with a croquill pen and India ink. They can be very effective when done with economy of line. Try for similar sketches from life models which you meet every day. Aim for basic line of gesture. Similar soft sketches can be drawn with brush and ink.

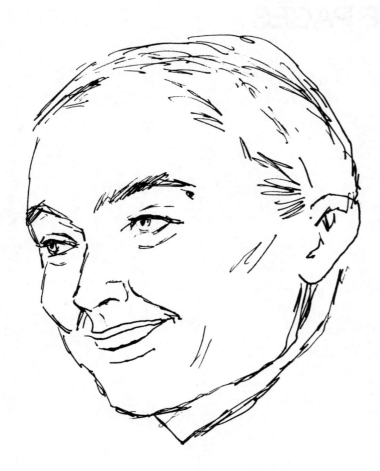

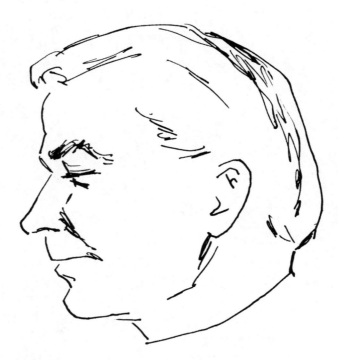

Practice these.

PRACTICE PAGES

OTHER BOOKS OF INTEREST

The Art of Cartooning by Jack Markow 0-399-51626-3/$9.00

Drawing Animals by Victor Perard, Gladys Emerson Cook and Joy Postle 0-399-51390-6/$10.00

Drawing People by Victor Perard and Rune Hagman 0-399-51385-X/$9.95

Sketching and Drawing for Children by Genevieve Vaughan-Jackson 0-399-51619-0/$10.00

By Tony Tallarico:

Drawing and Cartooning Comics 0-399-51946-7/$9.95

Drawing and Cartooning Dinosaurs 0-399-51814-2/$9.95

Drawing and Cartooning Monsters 0-399-51785-5/$9.95

Drawing and Cartooning Myths, Magic and Legends 0-399-52139-9/$9.95

TO ORDER CALL: 1-800-788-6262. Refer to Ad #609a

Perigee Books
A member of Penguin Putnam Inc.
375 Hudson Street
New York, NY 10014

*Prices subject to change

OTHER BOOKS OF INTEREST

<u>By Dick Gautier</u>

The Creative Cartoonist	0-399-51434-1/$12.00
Drawing and Cartooning 1,001 Caricatures	0-399-51911-4/$11.00
Drawing and Cartooning 1,001 Faces	0-399-51767-7/$11.95
Drawing and Cartooning 1,001 Figures in Action	0-399-51859-2/$10.95

<u>By Jack Hamm</u>

Cartooning the Head and Figure	0-399-50803-1/$9.95
Drawing and Cartooning for Laughs	0-399-51634-4/$9.95
Drawing Scenery	0-399-50806-6/$10.95
Drawing the Head and Figure	0-399-50791-4/$9.95
First Lessons in Drawing and Painting	0-399-51478-3/$11.95
How to Draw Animals	0-399-50802-3/$9.95

TO ORDER CALL: 1-800-788-6262. Refer to Ad #608a

Perigee Books
A member of Penguin Putnam Inc.
375 Hudson Street
New York, NY 10014

*Prices subject to change